The Art of Printing Photos

ON YOUR EPSON PRINTER

The Art of Printing Photos
ON YOUR EPSON® PRINTER

Michael Freeman & John Beardsworth

ELSEVIER

AMSTERDAM • BOSTON • HEIDELBERG • LONDON
NEW YORK • OXFORD • PARIS • SAN DIEGO
SAN FRANCISCO • SINGAPORE • SYDNEY • TOKYO

Focal Press is an imprint of Elsevier

Focal Press is an imprint of Elsevier
30 Corporate Drive, Suite 400, Burlington, MA 01803, USA
Linacre House, Jordan Hill, Oxford OX2 8DP, UK

Library of Congress Cataloging-in-Publication Data:
A catalog record for this book is available from the
Library of Congress.

ISBN-13: 978-0-240-81169-7

For information on all Focal Press publications visit
our website at www.focalpress.com

This book was conceived, designed, and produced by:
The Ilex Press, 210 High street, Lewes, BN7 2NS, UK

Publisher: Alastair Campbell
Creative Director: Peter Bridgewater
Managing Editor: Chris Gatcum
Senior Editor: Adam Juniper
Art Director: Julie Weir
Senior Designer: Emily Harbison
Designer: Ginny Zeal

Printed and bound in China

Get up to date news and information about this book at:
www.web-linked.com/arprus

Contents

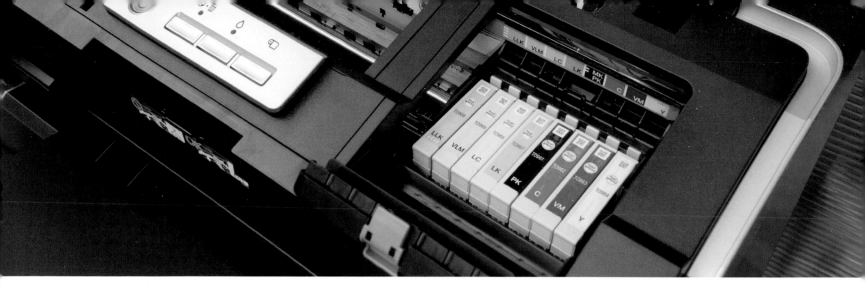

Introduction

WHEN DESKTOP PRINTER technology, pioneered largely by Epson, reached the point at which it looked possible that I could create my own prints to gallery quality, I felt it was a genuine revolution for photography. Potentially, it took a largely arcane craft out of the hands of specialists and photo labs and made it available to everyone. Every so often, this kind of thing occurs—a technological development that happened simply because it was possible—and has a huge effect on art and craft. It changes the way we think about and plan creative work. This is why it's called "disruptive technology," because it interferes unexpectedly with the normal order of business and activity. A delight for many, a rude surprise for some whose living depended on the old status quo.

For me it happened at a particularly useful time. I had just finished a three-year project on Sudan that was in the process of becoming a large book, and as part of this there was to be a major show of prints that would open in Washington DC and travel the United States for three years. And there were to be 70 prints, no small matter. The timing of our first printer, an Epson 400, was a coincidence; I was not seriously thinking that this would be a professional answer. But it was also a revelation. Even with just four inks and without calibration, the results were outstanding. I looked at the specifications of newer and larger machines, and found a color printing expert who knew the machines and did customized profiles, and realized that I could indeed realistically make prints to the same quality as a professional digital printing service. Maybe even better, given that I would be able to tweak and adjust on the spot, and would be able to follow my own instincts rather than attempt to describe subtle effects to someone else. This last was the real promise of desktop digital printing—making the final print fully part of the creative process. Making it personal. And in color if wanted.

PRINTER AND INKS

Personal control returns

In the days of wet printing, at the high end there were specialist darkroom printers, each with a specific style, and photographers who could afford it (editorial, advertising) would typically form a strong working relationship with one particular printer. Unless you did your own printing, this expensive and time-consuming solution was, frankly the only way to achieve great results. When you added color into the equation, it was even more difficult. None of the normal color printing methods offered a perfect answer, and all of them lacked full control. The standard, a C-type print, was printed from a negative, and this more than anything else pushed those photographers who worked to a final print towards shooting color negative.

IF, HOWEVER, YOU were a professional who worked for reproduction (magazines, especially), then you had a problem, because transparency film was what repro houses really wanted in order to make the separations prior to printing. To get from a Kodachrome, for example, to a C-type print involved making an internegative, and this had to be done optically. However good the process lens used for copying was, the interneg was inevitably softer than the original. Along came Cibachrome in the 1960s. This was (and still is, under the name Ilfochrome) a dye-destruction process that was positive to positive. In other words, direct printing from slide to paper. And, because it used azo dyes on a tri-acetate polyester base instead of traditional paper, it was essentially archival. Unlike C-types, it did not fade or discolor for years. Unfortunately, the polyester base meant absolutely no choice of base material. You either liked it or not. And colors were vivid and results relatively high in contrast. Again, you either liked this or not. So, even less creative control.

Lessons from dye-transfer

Having said this, there was a perfect color solution, but it was immensely complex and needed a huge amount of experience and skill. Also, it was discontinued by Kodak, to the dismay of everyone who knew it. This was the dye-transfer process, and its historical importance for digital printing is that it was the only color printing method that allowed a similar degree of control to the digital print.

Most of the history of the craft of printing concerns black-and-white, for the simple reason that, as we've just seen, traditional color processes allowed very little personal intervention—or little that was useful, at any

rate. Until, that is, the invention by Kodak of what was first called "wash-off relief" but was eventually marketed as "dye transfer." This extraordinarily demanding process, from which prints could be made from transparencies, involved making separation negatives in black-and-white, from which were enlarged three positives, one each for cyan, magenta, and yellow. The separation negatives were made by contact exposure, so there was no resolution loss. Any of that was confined, as in ordinary enlarger printing, to the enlargement stage. These enlarged positives, called matrices, were in gelatin relief and, in the final stage, each was soaked in the appropriate dye and carefully squeegeed down, in perfect register, one at a time, on the receiving paper. As you can imagine, achieving perfect register of three separations by hand was a serious task. I once spent a couple of days with two dye-transfer technicians—I can't think of a more appropriate term for the precision work involved—and this put me completely off the idea of trying it for myself. There would have been no time left for photography!

Dye-transfer prints have always been prized for their rich colors and permanence, and were adopted by photographers for whom subtle control, accuracy, and the ability to work in a personalized color palette were all essential. Two American photographers in particular were associated with dye-transfer—Eliot Porter and William Eggleston—but there will be no others as Kodak has abandoned the process. Allow me a diversion here in order to explain how important creative color decisions can be made at the stage of printing. This, after all, is close to the heart of what this book is about.

In the pre-digital days, most color photography took place in its totality inside the camera.

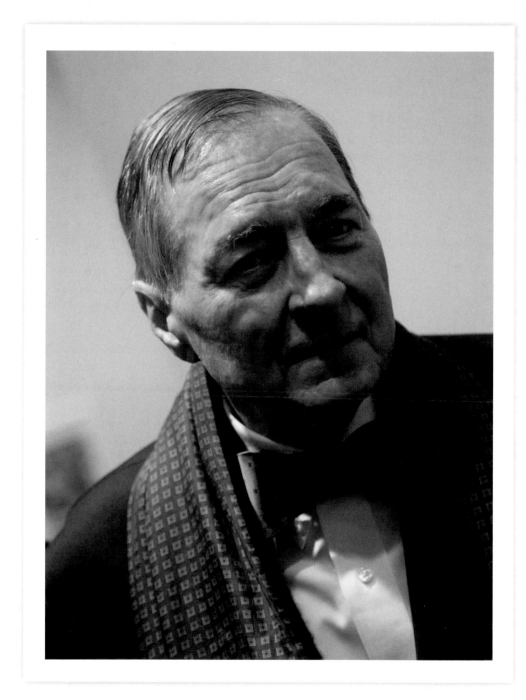

WILLIAM EGGLESTON
One of the masters of color control is seen here at the opening of a retrospective of his work at the Witney Museum, New York, in 2008.
Photo: Jason Kempin, courtesy Getty Images/Wire Image.

The exposure and filters determined almost everything, as the development processes after that offered little control. Most serious color photography for reproduction was, as I mentioned, on transparency film, so what you shot was what you had. Dye-transfer presented an alternative that has been matched since only by digital printing, and for the first time made it possible for a color photographer to develop a "look" based on the adjustment of individual colors.

Porter and Eggleston had quite different aesthetics when it came to subject matter, but shared an avoidance of the brash colors that tended to be identified with family snaps on beach holidays—"Kodak moments" and worse. Porter's interest was nature, and in the tradition of Henry David Thoreau and Ralph Waldo Emerson, he had a philosophical view that took in the continuum from fine detail to distant mountains. Porter's large-format images are dominated by detail, texture, and above all the surprising, often delicate, ephemeral colors of nature. In a typical Porter landscape, shot in Bryce Canyon in winter, spruce trees coated with snow exhibit the most delicate hues of blue and green, while behind them in the mist just a hint of redness clings to the national park's famous rock spires. This subtlety of color opposition and complement could have been achieved only in a dye-transfer print— or now, with digital printing.

Eggleston photographed the ordinary and often suburban Southern landscape of Mississippi. He discovered dye-transfer printing at a commercial lab, and said: "everything I saw was commercial work, like pictures of cigarette packs or perfume bottles, but the color saturation and the quality of the ink was overwhelming. I couldn't wait to see what a plain Eggleston picture would

look like with the same process. Every photograph I subsequently printed with the process seemed fantastic and each one seemed better than the previous one." Eggleston is credited with legitimizing color photography as fine art, through choosing to use saturated color as a way of heightening the reality of the ordinary, rather than using it to make lush idealizations.

Porter and Eggleston are probably the best known photographers who used dye-transfer, but within the advertising industry it was widely embraced as the workhorse of high-end retouching. The clone tool and its derivatives have become such a standard for retouching digital images, and so widely embraced even by purists who wouldn't remove even a cigarette butt from an image (think dust removal instead) that it is difficult to imagine life without it. Pre-digital color retouching was a very different matter. Even at the relatively simple, low-precision level of altering color casts over a region of the image, this was highly skillful. Everything had to be done by hand, and of course at the scale of the image. No zooming in and out. Instead, camel-hair brushes, airbrushes, and a magnifying glass were the retoucher's tools. The print, therefore, was the ideal place for retouching, such as cleaning up skin blemishes in a beauty shot. It was also essential for the then exotic special effects involving major manipulation that are now commonplace. The reason for the dye-transfer's excellence as a retouching medium was that the Kodak dyes it used—cyan, magenta, and yellow—could be used seamlessly for retouching as they all combined on the paper, and were not in layers.

Image opposite:
ELIOT PORTER
(1901 – 1989)
"Rufous Hummingbird, Tesuque, New Mexico, August 4, 1956"
Color Dye Transfer Print Photograph
Negative Date: 1942
Print Date: circa 1980s
Image Size: 16x12"
Mounted, signed in pencil on mount.

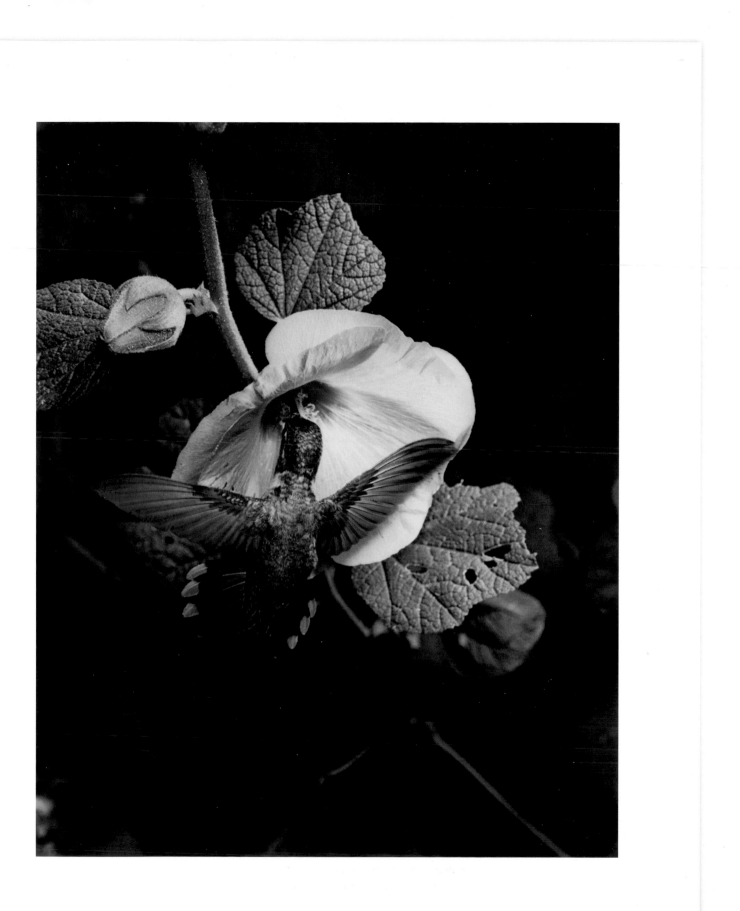

Color "look"

The key lesson from all this is the importance of a color "look." Most photographers combine two approaches to the overall color of an image— and a print. The first is to make sure that the default, standard color appearance is accurate. With this as a starting point, they then adjust and tweak the color of individual images.

HOWEVER, THERE IS a third procedure that can be added to these two, or even take their place. For anyone who wants to put a personal stamp on the overall color appearance of their work, this procedure involves adjusting the hue and saturation of individual colors before printing. We saw how this used to work with dye-transfer printing, where the cyan, magenta, and yellow dyes were individually laid down and adjusted. There are even more possibilities with digital printing; so many, in fact, that the chief problem is having a clear idea of what you want to achieve, then how best to do that. Although the means for adjusting color are technical, this is a creative procedure, and highly subjective, and usually subtle. Many people are initially tempted by strong departures from "standard" color, hence the popularity of special effects filters and non-naturalistic HDR tonemapping, endless examples of which are posted on photo sharing sites. A more mature approach takes a delicate view, with small shifts and alterations to balance, in much the same way as an experienced painter takes great care and patience in mixing pigments.

A strong development in this area is Adobe's new initiative to allow camera profiles to be imported and edited—and created. The DNG Profile Editor, launched in 2008, is an attempt to satisfy two needs often expressed by photographers. One is to be able to "nail" a precise color exactly as you think it should be, and this happens a great deal with reds. The other is the overall color "feel" or "look," often difficult to express precisely and pin down, because it depends on the combination of how different specific colors are presented. For example, camera manufacturers decide on this "look" when designing the cameras and their processing algorithms, just as film manufacturers used to. Raw converters from different software manufacturers differ also. You might like the the way the images "feel" right out of your camera; all well and good. But then again, you might think that something is lacking. Equally, you might like the features of Adobe's Camera Raw converter but prefer the default colors from, say, Phase One's C1. The solution is to be able to load, and then edit, profiles from a particular camera— and importantly, then be able to use those profiles in different software. The profiles should be portable, in other words. With a profiles editor this becomes possible. Adobe's DNG Profile Editor has the benefit of wide distribution and publicity, but it is worth noting that Phase One's C1 Pro also has a Looks Editor that functions in a similar way, and there is no doubt that such kinds of personalized color "look" profiling will become a part of all photographic processing software.

The reason I'm stressing such delicate, hard-to-pin-down color concerns, rather than the more mainstream color management issues and methods, is that the print is the place where these really matter. The screen may

be where all the work is done, and so of primary importance, but viewing images by transmitted light tends to mask all kinds of ills. A computer screen is like a film transparency in this respect—a wider dynamic range than the same image would have on a white paper print gives it more punch and makes it look superficially stronger. Not only this, but the ambient light greatly changes our perception of the color and brightness, a danger familiar to anyone who does image processing on a laptop. Prints are not like this. The range is much more restricted, limited by maximum reflectivity of white paper at one end, and the density of black pigment on the other. It's worth stressing at this point one of the basics of the range of light. The dynamic range of a scene—and this includes an image in your eye's field of view, whether on a screen or as a print, is the product of two things. One is the light reaching the scene, the other is the amount of light reflected from surfaces. The difference is huge. The maximum reflected range, from white surface to printed black, is no more than about 30:1, while the range within the screen of an 8-bit monitor is in the region of 300-400:1. Step back from the monitor, view it at maximum brightness in a dark room, and the range of the whole scene shoots up to the thousands:1. Thus, reflected light plays a minor role in the overall range of a scene. The light sources rule, in other words.

Perhaps even more important is that the eye is more comfortable and consistent in its response to viewing a reflected print image than it is to a backlit image. Unless you deliberately play a spotlight on the print alone, your eye accommodates to the light level and color very efficiently and quickly, and manages to see a print as looking much the same under a remarkable range of

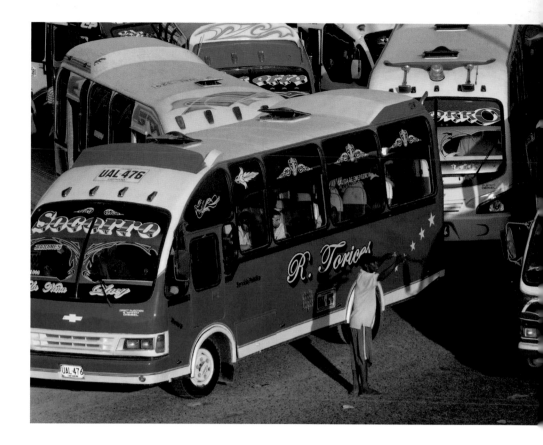

conditions. This does not mean that you should ignore the essential matter of optimum viewing conditions, but the eye does manage well without great help. As an aside, lighting techniques for displaying prints, as we'll see on page 178 can be especially effective for the precise reason that the eye does not expect significant variations in the brightness of a print image. Possibly the most effective professional display technique of all is a tightly collimated and lensed spot thrown from a distance (and therefore itself not obvious), masked down precisely with a small frame in front of the lamp's lens. Done accurately, so that the beam edges coincide exactly with the edges of either the image area or the frame, this makes it possible to lift the overall brightness of the image considerably higher than the surroundings, without the viewer being aware.

This shot of a bus stop, in Cartagena, Colombia, provides a good example of a rich color look that would concern any photographer at printing time.

Inkjet basics

Impressive though an image may be on a computer screen, a well-produced photographic print continues to be the ultimate result in photography. I believe we should do what our photography deserves and produce more prints of our work, and inkjet photo printing makes this easier than ever.

BEFORE WE DELVE into the specifics of Epson's particular inkjet technology, which is fundamentally different from its competitors, I'll go over the basics of what inkjet printing is all about.

Let's break up the word inkjet into "ink" and "jet." Liquid ink is forced through a series of microscopic nozzles, resulting in a tiny droplet of ink being jetted out, or fired at the media, which in our case is specially coated photo paper. Some people think of the ink being sprayed out, but as there is tight control over the release of ink droplets, the term "fire" seems more appropriate.

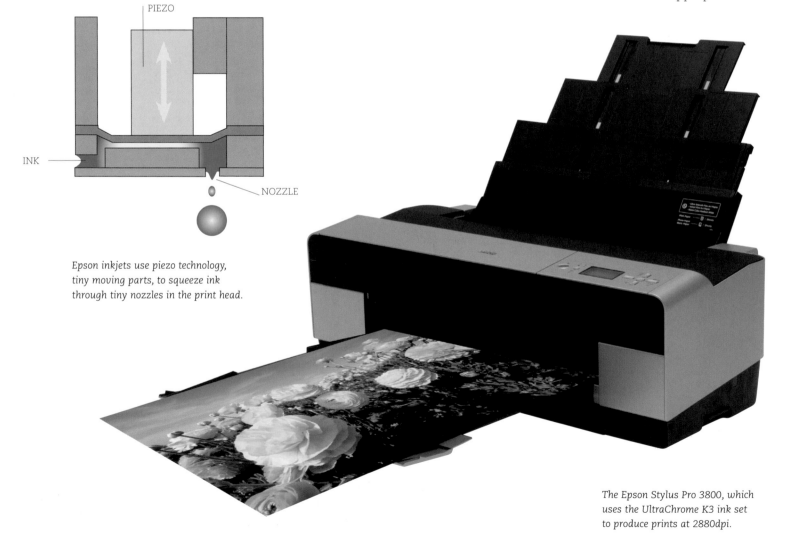

PIEZO

INK

NOZZLE

Epson inkjets use piezo technology, tiny moving parts, to squeeze ink through tiny nozzles in the print head.

The Epson Stylus Pro 3800, which uses the UltraChrome K3 ink set to produce prints at 2880dpi.

Every second, many hundreds of thousands of ink droplets are fired in several colors, and sometimes in different sizes, onto the paper. To cover the areas required, the print head moves across the platen from side to side, while the paper is advanced very accurately in time with sweeps of the head.

In some models or print modes the print head will only print when the head is traveling in one direction. This is called unidirectional printing, and is less common these days. More usually, printing is maintained in both directions, called bidirectional printing, which increases the printing speed as there is no need to wait for the head to reach its starting position after the end of one traverse.

The density of the dots that a print head can lay down in a single pass is not adequate for photo-image depth, so the image is built up in a series of passes. Sometimes you can see this when a print has been interrupted. The unfinished edge of the printed area will have a fall-off in detail and density, showing how the image is actually built up, with one pass overlaying another.

If you magnify a portion of an inkjet print, you will see that the structure of the detail and color is formed from a pattern of dots, with each dot formed by an ink droplet. What is important though is that when we examine a color photo print from a sensible viewing distance, the color and tonality are lifelike and contiguous.

Two printer heads, the above from a printer with Epson UltraChrome HD inks, and the lower one an old-fashioned ink-head-in-cartridge design with only three inks.

Ink flow and print heads

Epson's inkjet technology pumps liquid ink through the nozzles using what is known as a "piezoelectric" method where an electric current causes the ink chamber to change shape and pump microscopic droplets of ink. This differs from thermal inkjet technologies such as Canon's "Bubble Jet" method where the ink is heated and vaporizes, blowing out through the head nozzle and immediately re-condensing as an ink droplet as it reaches the paper.

Epson says that its technology is less stressful on the inks and allows more precise formation and placement of drops. There used to be a problem with thermal print heads wearing out and requiring replacement, but Epson has been able to guarantee its print heads for the life of the printer. Epson inkjet print heads are not normally user-replaceable.

We must not forget the print cartridges or ink tanks. Epson cartridges have a complex, patented breathing system, using a specially developed valve to ensure normal ink flow. It's important to avoid particles of dust or other debris from getting into the tiny print-head chambers and blocking the nozzles, yet at the same time allowing cartridges to be removed without ink leaking or air being introduced. A duty-cycle chip logs the ink consumption in each cartridge. The moment the ink supply falls to a preset level, a

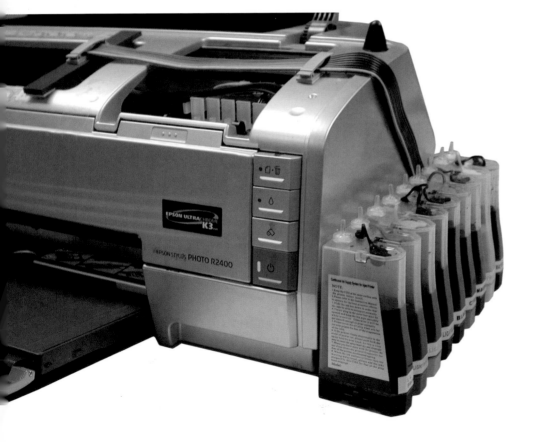

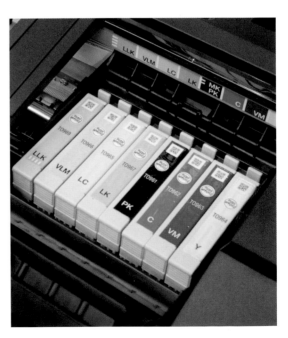

Larger format printers, or specially adapted desktop printers, leave the cartridges in one place and transfer the ink by means of a CIS.

warning is generated that the cartridge will soon run out. More important, the cartridge will lock itself once the level becomes critically low. Epson aggressively defends its patented designs against third-party printer ink suppliers.

In larger Epson inkjet printer models, the ink cartridges don't ride above the print head as they do in more compact models. Instead tubes feed inks from the stationary cartridges to the moving print head, which allows for much larger cartridges.

There is a common perception that inkjet printer inks are overpriced. If you do a lot of printing, switching to a printer model with larger ink cartridges may prove to be more economical. Another option is to convert a printer to a third party CIS, or continuous ink system; this choice can work well if you want to use specialist inksets, particularly for black and white. CIS mechanisms and inks vary, and it's best to see a specific system in use and examine the final output with your own eyes before deciding if you want to move in that direction.

Piezo inkjet

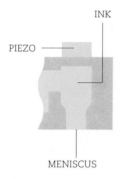

INK

PIEZO

MENISCUS

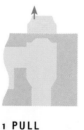

1 PULL
The meniscus layer is concave when no ink is being ejected. The piezo moves backward to begin the process.

2 PUSH
Forward motion of piezo breaks the meniscus and forms an ink droplet.

3 PULL
The piezo pulling back separates the droplet from ink, and it continues towards the paper.

Thermal inkjet

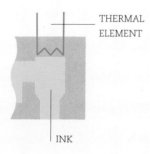

THERMAL ELEMENT

INK

1 HEAT
The change in temperature forms bubbles.

2 HEAT
The bubble reaches a critical size which pushes an ink droplet out.

3 ELEMENT OFF
Without heat, the bubble dissipates and the process can be repeated.

Droplets and resolution

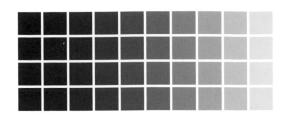

It's very important not to get too confused about drops, dots, and pixels. An inkjet printer lays down droplets of ink to construct an image. Some printers produce variable-sized droplets, ranging from around 10 picoliters to as little as 1 or 2 picoliters. Each ink droplet creates one printed dot. The density of the array of dots produced by a printer is measured in terms of dots per inch, or dpi. That is the printer resolution.

Pixels

Computers describe images in terms of solid regions of color, usually square, called pixels.

Halftones

Traditional color printing uses different sized dots arranged in a halftone. The bigger the dots, the more ink droplets are used to form them.

Pixels and dots, ppi and dpi

Image resolution is different from printer resolution. It takes several dots of ink to reproduce a single image pixel, and an image file will usually have a property that defines its printed size—in other words, the number of image pixels that will be printed along one inch. This is image resolution, and is usually called pixels per inch, or "ppi."

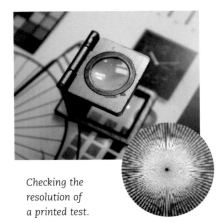

Checking the resolution of a printed test.

Annoyingly, the acronyms dpi and ppi are often misused. For instance, you may read that your printer has a nozzle spacing of, say, 180 nozzles per inch. If this printer has eight colors, each inch of paper gets eight print head passes at 180 nozzles per inch, so the printer is quoted as having 1440dpi, a more impressive figure for marketing.

Diffusion

Since the Epson Stylus 400, inkjet printing arranges ink droplets in a diffusion pattern as each dot from the ink head is the same size.

It's actually quite simple—ppi relates to the printed resolution in terms of image pixels, while dpi should only refer to the printed resolution in terms of printer dots. When you prepare an image file for printing, you normally need to focus on printed resolution, ppi. If you have a file that is 200ppi, then 200 pixels will be printed onto a line of one inch. Let's say the image has been cropped to 3000×2000 pixels. Divide the picture's size by 200 and you get the printed size of the image in inches. In this case, it's 15×10 inches.

Image Size		
Pixel Dimensions: 2.29M		
Width: 1000	pixels	OK
Height: 802	pixels	Cancel
		Auto...
Document Size:		
Width: 8.47	cm	
Height: 6.79	cm	
Resolution: 300	pixels/inch	
☑ Scale Styles		
☑ Constrain Proportions		
☑ Resample Image:		
Bicubic (best for smooth gradients)		

The Photoshop Image Size dialog makes plain that it works in pixels per inch, as opposed to dots per inch.

By altering the printed resolution of the file, without "resampling" or changing the actual image data, you can change the size at which the picture prints. If we increase the resolution to 300ppi, more image pixels are squeezed into a single inch, so the overall size of the print drops to 10×6.7 inches. Once you go beyond 300ppi though, any improvement in image quality is less likely to be detectable to the human eye.

Alternatively, let's say we reduce the printed resolution to 100ppi. The printed size becomes 30×20 inches, a larger print, but the more we reduce the resolution, the more likely it is that pixels will start to be visible on the print. The image will also look softer, especially close-up. As a rule of thumb, you are unlikely to get away with a print resolution less than 180ppi.

Low resolution images mean that line art can become blocky.

At a higher resolution, the detail is clearer.

Inkjet printers can overlap droplets for a smoother appearance.

Resolution comparison

Images prepared for this book are typically a minimum of 300ppi, however here you can see the same file is prepared at lower ppi settings. The richness of areas of solid color is not affected, but the detail is lost.

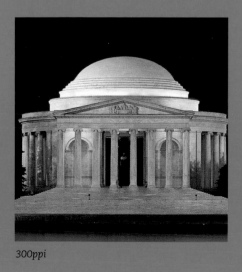

300ppi

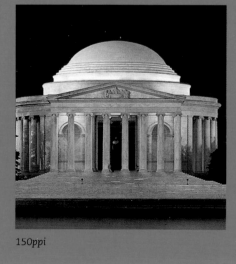

150ppi

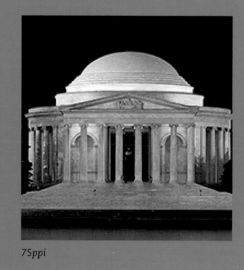

75ppi

CMYK inks

Print presses have traditionally used four colors—cyan, magenta, yellow, and black. This "CMYK" combination differs from camera sensors, computer screens, and other devices that record or transmit color using red, green, and blue, or "RGB." Inks need to reflect light off the paper, and while the three primary colors can produce a black, the results rarely match those from a pure black ink—hence the K in CMYK. By varying the mix of C, M, and Y, inks can reproduce intermediate hues through the visible color range.

THE EXTREMES OF the range of hues that a printer can accurately reproduce is known as its color gamut—a large gamut generally being preferable to a smaller one. The ability to produce intermediate colors and tones is limited by the way C, M, and Y ink dots can be arranged in their microscopic patterns, as well as the purity of the inks. If ink drops mix together before they can dry, or the quality or consistency of the ink dyes or pigments is not ideal, color variations can cause problems with accurate rendition.

Lighter shades of cyan and magenta are often used to supplement the standard C and M inks. These lighter shades, also referred to as photo cyan and photo magenta, produce smoother transitions in areas with subtle gradations or skin tones. By increasing the range of dot densities, supplementary photo cyan and photo magenta inks also reduce the potential graininess of a print.

In theory, you only need C, M, Y, and K, but in reality some hues are more easily produced than others, so printer designers have introduced supplementary inks. The Epson Stylus Photo R1900, for example, employs orange and red inks to expand the red area of the printer's gamut, which has been a relatively weak region for inkjet printers.

Cyan, Magenta, and Yellow are the "primary" colors of the mixing process as illustrated opposite, though the Key (black) has long been established as a necessary component since it reduces the need to mix three inks together at 100%. Even if a perfect mix could be guarnteed, there is a risk of paper saturation.

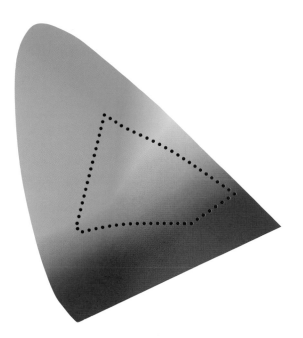

Three inks bad

The subtractive color model—that is subtracting from white by adding varing amount of your primaries—theoretically only needs three inks; cyan, magenta, and yellow. In practice, the results are poor.

CMYK

CMY

*The limits of a typical CMYK gamut, marked as a dotted line, plotted over a representation of the whole range of colors (using the L*A*B system).*

Another recent trend has been the introduction of extra black or grayscale inks. Gray and black neutrality in photographic images is hard to achieve when printing with only color dots. With more shades of black available to the printer, control of neutral areas in color images is much improved, and much better quality black-and-white prints can be produced.

A matt black ink has also been added to most high-end inkjet photo printers. This ink is designed specifically for matt-surface fine art papers and gives a deeper, denser black result than inks optimized for glossy and semi-gloss papers.

The CMKY primaries are not just the basis of inkjet color printing, but commercial printing presses too.

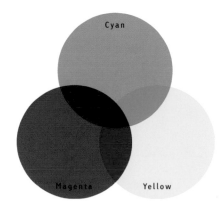

Epson inks

Epson produces three families of inkjet printer inks: DuraBrite, Claria, and UltraChrome. DuraBrite is primarily for use with plain papers and is a pigmented ink that has very good water resistance qualities and retains its vibrance on plain papers. It's not too bad for printing photos on photo paper, but is not as good for photo printing as either Epson's dye-based Claria inks or the sophisticated fine art quality, pigmented UltraChrome inks. As DuraBrite is not pitched as a high-quality photo ink-set, we'll focus on Epson's Claria and UltraChrome inks.

MOST PEOPLE WHO print relatively small photo prints, up to A4 (letter) or A3 (tabloid), prefer a glossy finish. Dye-based inks are purely liquid and are absorbed into the top layer of the paper's surface, maintaining the shine of glossy photo paper. Pigment inks, like Epson DuraBrite and UltraChrome, aren't easily absorbed as the inks contain a suspension of tiny pigment particles that lie on the surface of the paper and disrupt the natural shine of the paper's coated surface.

Epson developed Claria dye-based inks primarily for use with glossy and semi-gloss photo papers. To overcome dye-based inks' reputation for fading colors, the inks are designed to outlast traditional silver halide lab prints. They are also splash-resistant, and you can wipe water off and let the print dry again without any ink running. Dye-based inks like Claria also have a reputation for more vibrant colors than pigmented inks, plus finer grain and deeper blacks, especially when used with glossy paper.

However, dye inks perform less well when used with papers that have rough surfaces, like plain paper and fine art matt papers. The ink spreads and dots tend to merge into each other, resulting in loss of detail, contrast, and color accuracy. This is why Epson developed specific pigment inks for these applications.

The Epson UltraChrome K2 inkset uses seven cartridges, including a gloss optimizer. Matte or photo black have to be swapped out.

The Epson UltraChrome K3 inkset uses eight cartridges (matte or photo black have to be swapped out).

UltraChrome

As established, dye-based inks did not produce good enough results on matt papers. Secondly, because of their chemical structure, pigment-based inks are naturally more resistant to fading due to light or chemical vapors from cleaning fluids.

However, there were several problems that Epson had to solve. The color gamut of pigment inks was much smaller than the best dye-based inks. Printing with pigment inks onto glossy papers also produced an uneven gloss because the light areas, where less ink was laid down, retained more gloss than heavily colored areas where the pigment particles lie on the paper's glossy surface and reduce its shine. There were also issues concerning the granularity of the pigment particles and the consistency with which they would lie on the paper surface. Metamerism, where colors, especially gray tones, appear unusually different under different lighting conditions, was also a problem.

To overcome all this, Epson developed a process that wrapped a polymer coat around the pigment particles, which stopped them clumping and improved performance on glossy paper. Improved formulations radically improved color gamut too, and UltraChrome has now evolved into two varieties: UltraChrome K3 for fine art printing and UltraChrome Hi-Gloss for dual use with both standard photo papers and fine art or matt papers.

Vivid sunlit subjects and strong colors will benefit from Epson's gloss optimizer technology, which adds to the permanence of the print—under display conditions it should last 80 years.

Without gloss optimizer
Surface is uneven.

With gloss optimizer
Clear areas of the page between ink droplets are filled with gloss optimizer for a shinier surface.

Through steady refinement of the formulations, pigmented inks now have less uneven appearance on glossy paper, but Epson's UltraChrome Hi-Gloss introduced an additional fix for this issue—a gloss optimizer. This isn't actually an ink, but a clear polymer-based liquid that is "printed" when no color ink is used. The result is an even shine across the whole print surface. The downside is the loss of grayscale inks in the cartridge line-up, so if you really value black-and-white printing, you may be better off using an UltraChrome K3 printer.

UltraChrome K3

First-generation UltraChrome expanded the color gamut of Epson's pigmented inks and improved the surface uniformity of ink

Epson 7900 which uses the UltraChrome HDR 10-ink system.

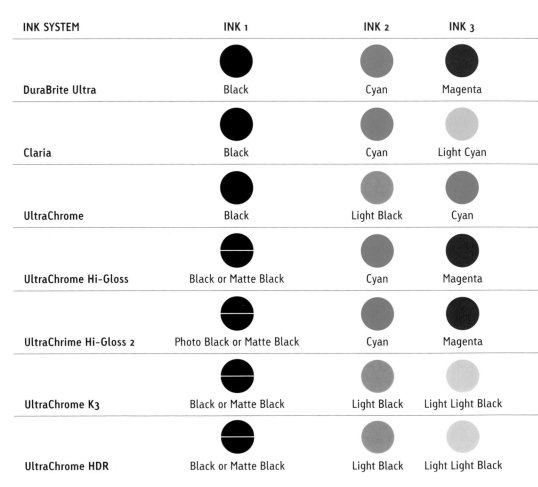

INK SYSTEM	INK 1	INK 2	INK 3
DuraBrite Ultra	Black	Cyan	Magenta
Claria	Black	Cyan	Light Cyan
UltraChrome	Black	Light Black	Cyan
UltraChrome Hi-Gloss	Black or Matte Black	Cyan	Magenta
UltraChrime Hi-Gloss 2	Photo Black or Matte Black	Cyan	Magenta
UltraChrome K3	Black or Matte Black	Light Black	Light Light Black
UltraChrome HDR	Black or Matte Black	Light Black	Light Light Black

coverage, while retaining the traditional pigment ink advantages of compatibility with fine art papers and fade-resistance. With the advent of UltraChrome K3—the secret is in the suffix—Epson directly addressed the issue of improving grayscale reproduction. In addition to the standard black ink and single "Light Black" ink introduced with the original UltraChrome inkset, Epson added an additional lighter density of black, or "Light Light Black"— hence the K3 or three blacks. UltraChrome K3 also reduced metamerism characteristics and improved the problem of bronzing, where the shine on a glossy print can take on a metallic bronze-like tint under certain lighting conditions. The inkset also boasts near-instant color stability, so you don't have

to wait for a period before checking and evaluating print color.

The color gamut of UltraChrome K3 was further improved to exceed that of typical silver halide chemical process color printing. UltraChrome K3 has since been further enhanced with the introduction of a vivid magenta ink in some of Epson's latest printer models, including the Epson Stylus Photo R2880, Stylus Pro R4880, and Stylus Pro R7880—the common theme here being the "88" designation in the model number. UltraChrome K3 has no gloss optimizer like UltraChrome Hi-Gloss, but later in the book you will see how you can effectively make your printer optimize the light areas of a print to make the ink gloss more uniform.

Black and white

The "K3" Suffix is a clue to what Epson had done —"K " being the symbol for black, as in CMYK, or Cyan, Magenta, Yellow, Black. The "3" in K3 indicates the inclusion of three densities of black ink, rather than the two of the original UltraChrome ink set. So now we have Black (matt and gloss versions), Light Black, and Light Light Black. The introduction of the second light black ink reduced the requirement color ink input when printing gray tones to much lower levels. UltraChrome K3 inks are now helping photographers produce black-and-white prints that very closely match the subtle qualities of traditional black-and-white prints.

INK 4	INK 5	INK 6	INK 7	INK 8	INK 9	INK 10
Yellow						
Magenta	Light Magenta	Yellow				
Magenta	Yellow	Red	Blue			
Yellow	Red	Blue	Gloss Optimizer			
Yellow	Red	Orange	Gloss Optimizer			
Cyan	Light Cyan	Vivid Magenta	Light Magenta	Yellow		
Cyan	Light Cyan	Magenta	Light Magenta	Yellow	Orange	Green

Maintenance

Inkjet printers are designed to work with minimal maintenance and are therefore not particularly difficult or time consuming to maintain. But sometimes there are areas that may need attention.

CL093A QP100550

Head alignment

When your new inkjet printer arrives, one of the first things you need to do is print one or more test sheets. Apart from revealing any manufacturing fault that merit returning the printer to the vendor, most printers include head auto-alignment features, which sense the test print and make the necessary head-alignment adjustments. If auto-head alignment is not available, you will need to examine the test prints and enter numeric choices as prompted according to what you see on the test print. Once this procedure is complete, the printer should print reliably.

Nozzle clearing

You may see bands in your prints that indicate a nozzle in the print head has become blocked. This is usually dealt with by running a print-head cleaning cycle. Blocked nozzles are most likely to occur after an extended period during which the printer has not been used, in which case it can be a good idea to run a nozzle check print before starting the printing session. This avoids unnecessary wastage of photo paper.

You can print the Nozzle Check pattern using the printer's driver software's Utility tab.

Inspect the paper path

The printer should be located so that nothing interferes with the paper feeding into or out of the printer. Ideally it should be positioned where dust or fluff can't fall on a still-damp print; this also reduces the risk of any such material finding its way into the more delicate parts of the paper path within the printer. If you find that this has happened, try gently cleaning the areas, perhaps with a desk vacuum cleaner or a camera dust blower-brush, but without touching internal parts. If there has been a paper jam, ensure that any scraps of paper that have been left behind inside the printer are found and removed. Always take a second look.

Powering off

It's important to switch off your printer by using its own power switch, not the main ones. This ensures that the printer can follow its regular power-down procedure, including the appropriate parking of the print head over a protective seal that prevents it from drying out.

Maintenance cartridge

Some Epson printer models have a maintenance reservoir tank to collect waste ink that is flushed through the print head during nozzle cleaning or after a cartridge swap. You will be alerted when the reservoir cartridge is becoming full. Eventually you will need to replace the cartridge with a new empty one.

Smaller Epson printers don't have a replaceable maintenance cartridge. Instead, a special pad in the base of the printer soaks up excess flushed ink. In theory, the pad could become saturated and threaten to cause a leak. However, this would be a highly unusual occurrence as such printer models are designed to stop working in advance of the pad becoming saturated. Also, this is usually well past the expected life cycle of the printer unit.

Epson Stylus 3800 replaceable maintanence cartridge.

A used maintenance cartridge from an Epson 9600. Note that, just like the ink cartridges, a chip monitors the use and alerts you when the cartridge needs to be replaced.

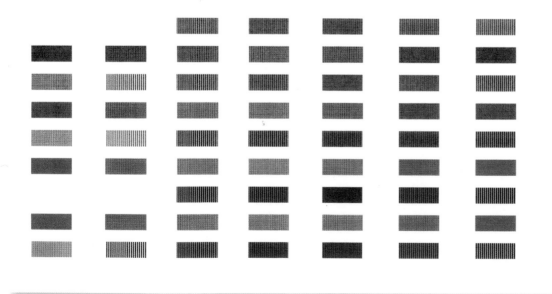

Your printer's alignment procedure will offer you some options, from which you should select the most even areas from a pattern like this.

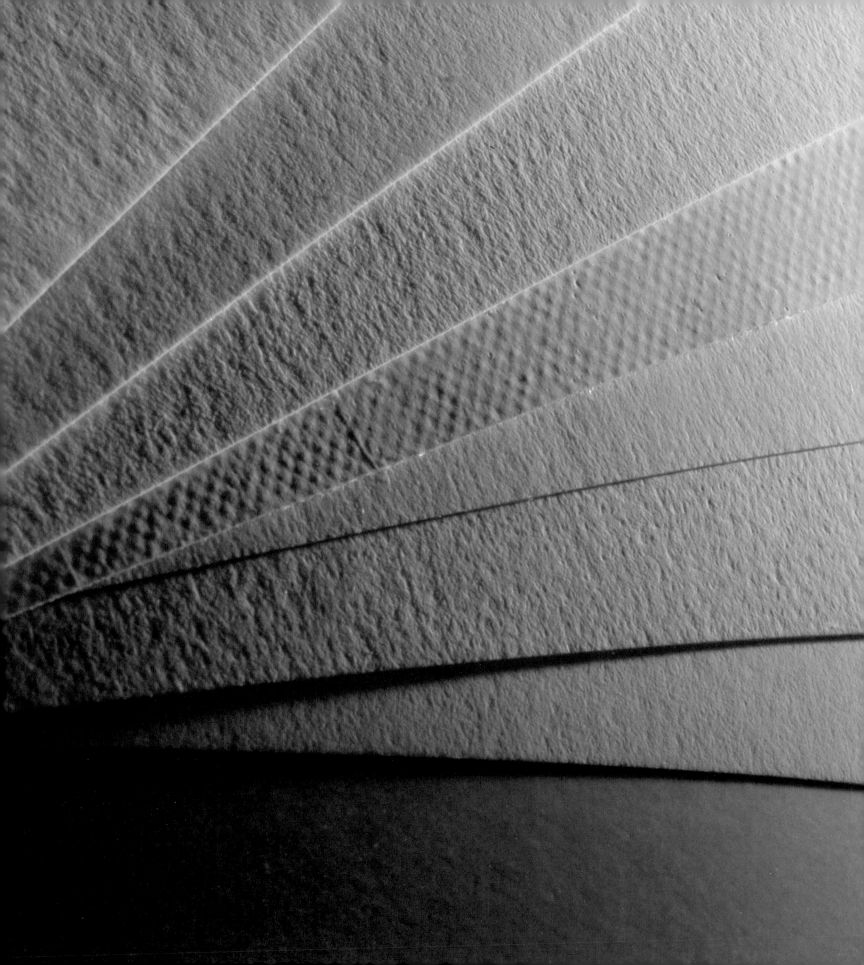

PAPER

Paper types and weights

One of the beauties of inkjet printing is that almost any paper can be used—normally but not necessarily coated—to produce significantly different effects on the character of the image.

THERE IS A KEY DIFFERENCE between traditional emulsion-coated photographic printing and the inkjet process, even though both use coated paper. Inkjet coatings have no need to be light-sensitive and so can be applied to any kind and weight of paper—as well as to non-paper substrates such as canvas. In practice, this opens up the range of available print surfaces enormously, and if you are prepared to experiment with non-Epson products, there is no limit.

Many of the best inkjet papers are produced by paper mills of long standing, such as Hahnemuehle and Somerset, who over a long period of time (in some cases centuries) have developed specific products with fine but important distinctions. Brand descriptions cloud these differences, but we can distinguish between paper quality, composition, weight, texture, surface, acid content, brightness, and whiteness.

Paper manufacture begins with the pulp; a suspension of cellulose fibers in water applied to a fine mesh. One of the purest forms of cellulose comes from the cotton plant. The highest-quality fiber is rag, which comes from the parts used in textile manufacture. Of lower quality is cotton linter, a by-product of the earlier ginning process.

Further distinctions are made between handmade, mould-made, and machine-made papers. Handmade paper is produced by manually dipping the wire mesh screen, on a frame, into the pulp and withdrawing it slowly so that it coats completely. Performed skillfully, the result is excellent, with characteristic "deckled" (roughly feathered) edges. Of course, the paper is not consistent from one sheet to the next. This works against identical images in an edition, which may or may not be desirable. Mould-made paper uses a cylinder covered with mesh, but in common with handmade paper has the advantage that the fibers are not all aligned in the same direction—as happens

UNCOATED PAPER

COATED PAPER

The effect of printing on uncoated paper is far from attractive. The inks soak into the fibers and lose gamut and density.

with the faster, more economical machine-made paper—and the sheets are therefore stronger. Weight also affects the paper's resistance to cockling and curling when the ink dries. Sizing is a treatment employed to make paper more water-resistant and normally uses gelatin, rosin, or aquapel. It reduces the absorbency of the paper, but can adversely affect its archival qualities because of the acidic effect of the fixer chemicals.

A variety of texture and weight

This range of fine-art inkjet papers from the four-centuries-old Hahnemuehle German mill, covers a variety of textures, surface finishes, and weights. The differences in appearance depend greatly on the angle to the light and the hardness of the lighting. As for weight, art paper is generally 250gsm and over.

There are varieties even within the range of canvases, including differences in texture and surface coating (shown here are matt and gloss in this range from Hahnemuehle).

Epson photo papers comparison

	Weight	Min Size	Max size	Roll option?	Pro Print	Archival	Museum display	Proof
Ultra premium Photo Paper Lustre	260	8.5 × 11	17 × 22	✓	✓	✓		
Premium Semi-gloss Photo Paper	250	4 × 6	13 × 19	✓	✓	✓		
Ultra Premium Presentation Paper Matte		8.5 × 111	17 × 22		✓			
Singleweight Matte Paper		13 × 19	17 × 22	✓	✓			
Watercolor Paper Radiant White		13 × 19	13 × 19		✓			
Presentation Paper Matte	192	8.5 × 11	17 × 22	✓		✓		
Enhanced Matte Posterboard		24 × 30	30 × 40			✓		
Velvet Fine Art		8.5 × 11	17 × 22		✓		✓	
Somerset® Velvet	505 (255 roll)	24 × 30	36 × 44	✓	✓		✓	
UltraSmooth Fine Art	250	13 × 19	24 × 30	✓	✓	✓	✓	
DuPont Commercial Glossy Proof		13 × 19	13 × 19					✓
Proofing Paper Commercial Semimatte		13 × 19	13 × 19					✓
Posterboard Semigloss	870	20.25 × 28.7	28.7× 40.6					

Ingredients and manufacture

Moving into more detail, inkjet photo papers are broadly divided into two distinct types—fiber-based (FB), and resin coated (RC). Most high quality photo papers are fiber-based and are made from premium grade paper fibers, so they are essentially what most people have traditionally understood paper to be. The photograph is printed directly onto fiber-based paper.

RESIN COATED PAPER is a relatively modern product, where the paper is actually sealed in an envelope of plastic, and the image is printed onto the plastic or other layers. The paper itself simply provides a white background, not the actual "substrate" or surface that physically holds the image. Nearly all inexpensive glossy and semi-glossy photo papers are resin coated.

Fiber papers

Fiber-based papers have a natural texture, and don't have the plastic feel of resin coated papers. Their weight and thickness is much-valued and can add to the overall quality and presentation of a fine art photo print.

Most fiber-based paper is manufactured from wood pulp, and made in bulk using modern industrial paper milling techniques. More exotic papers are made from cotton fibers or blended with wood fibers. So-called "rag" type papers contain a high proportion of cotton fibers and some of that fiber is still sourced from recycled cotton fabrics.

Alpha cellulose

One phrase to look out for is "alpha cellulose," the very best quality paper fiber. Sourced from either wood pulp or cotton, it's a highly purified fiber that is very stable and valued for papers used for archival purposes. The technical definition of alpha cellulose is a long, durable fiber sourced from plants that is highly purified, with all original soluble matter removed, leaving an insoluble material for making highly stable paper products. Alpha cellulose may be derived from wood, linen, cotton, and other plant materials. The term alpha cellulose is popularly used in the marketing of archival quality fine art papers.

Many paper mills produce vast rolls as paper from wood pulp, though these papers are less suited for inkjet use.

Fiber glossy

In the last few years, paper manufacturers have responded to fine art photographers' demands for an inkjet equivalent to traditional darkroom papers and have developed a type of inkjet paper known as "fiber glossy." New fiber glossy papers are continually being introduced.

These new papers are fiber-based and no longer have the cheap feel of plastic or its high-gloss appearance, which is a big step forward. To some extent, they feel like unglazed fiber-based darkroom papers, and they have become popular for fine art color printing and especially for black and white work. Not all photographers like them, because they are not quite as close to

When paper is manufactured finely calibrated machines stretch and flatten the paper before the coating is applied.

Uncoated paper absorption

Coated paper absorption

darkroom paper as claimed, or because they notice unusual surface textures and faint stippling.

Rather than referring back to previous materials, it's better to judge fiber-glossy paper on its own merits, so the real question is whether the finished fiber-glossy print looks and feels like a skillfully-crafted, high quality photograph. The best answer one can give is that it's a fast-changing area and these papers are worth trying. Only you can decide if the resulting prints meet or exceed your standards.

Traditional handmade paper

Many consider handmade mold-made paper to be the very highest quality. A mold consists of a metal wire mesh, which is fixed to a solid frame and held flat as it is dipped into a vat filled with liquid fiber pulp. The mold is manipulated to strain off a layer of pulp that is spread evenly across the mold mesh and then lifted out. The wet sheet of fiber pulp is then turned out carefully onto felt. Several layers of wet paper and felt are formed and then pressed to extract most of the remaining water. They are then hung out to dry, before being "sized," or treated, to make the surface smooth and receptive to ink. Then comes "calendaring" where the paper is pressed and passed through rollers to further improve the surface finish.

"Mold-made" paper is similar, but is manufactured on a cylindrical mold. More productive than the handmade method, mold-made paper is often called handmade, but there are distinct differences. The mold is not held by hand. A rotating cylinder mold collects the wet paper pulp from a vat. The resulting sheets are then placed on to a continuously moving felt and cylinder-dried.

For inkjet use, the manufacturer adds an invisible coating to one side of handmade or mold-made fiber-based papers. Mold-made paper sheets have the same much-prized characteristically uneven "deckle" formed edges of handmade mold paper, but the mechanical process results in a more even production quality and, of course, it's cheaper to produce. These are therefore high quality papers best suited to fine art, limited edition use.

Resin coated papers

Since the 1960s, resin-coated or RC photo papers have been popular for darkroom work and now, increasingly, in inkjet photo printing. They are manufactured in very large quantities and are cheaper than high quality fiber-based papers.

These types of papers have a polyethylene coating that sandwiches a layer of low grade paper fiber. This provides a very smooth and consistent surface while preventing water or chemicals reaching and damaging the paper or causing problems like curling and

Coated paper has a dramatically wider color gamut (range) than uncoated paper. This comparison shows a uncoated color space (dotted line) and a coated color space (dashed line).

Coated paper (right) allows for richer images with a wider dynamic range, since highlights are preserved (ink does not seep into even the smallest specular) and dark areas do not lose their richness through spread.

cockling. The resin coating also permits additional surface material layers to be added. A variety of surface finishes can be produced, including high gloss, semi gloss, luster, satin, and even matte.

Most inkjet photo papers are of the resin coated type and are best used with dye-based inkjet photo printers. Specialist matte papers for inkjet photo printing will be coated to optimize the reception of ink onto the paper surface and are often treated with a mild alkali like calcium carbonate to help negate the effects of acidity in the environment that can lead to ink fading.

A technical difference between matte papers and others is that matte papers can absorb a lot more ink. Dye-based inks do not perform as well on matte papers as pigmented inks. This is because dye inks are drawn into the surface of matte papers and spread out,

affecting dot definition and so reducing color clarity, tonal depth, and contrast. Pigmented inks lie mainly on the surface of the paper and the ink drops do not spread out as much, so definition and color density are not so badly compromised.

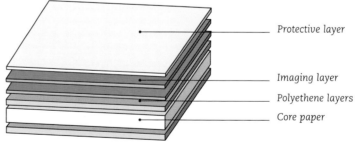

Protective layer

Imaging layer

Polyethene layers

Core paper

Inkjet paper manufacturer Pictorico use a crystal coating technology between the surface protection and the substrate that draws surplus ink into pores smaller than an ink droplet, reducing ink spread.

Sizes and quantities

Photo inkjet paper comes in all sorts of sizes and quantities, from small packs of sheets cut to common formats, up to boxes of hundreds of sheets and rolls of paper that you cut as required. Each option fits a particular need and has its own pros and cons.

Pack sizes

Good inkjet photo paper is not cheap, and it makes little sense to buy it in quantities greater than you need. This certainly applies to new papers, so if you want to sample papers with which you aren't already familiar, paper manufacturer or suppliers usually supply sample packs of maybe a couple of sheets of each paper in their range. These can be free at trade shows or attached to magazines, or a quick phone call to their sales department might lead to a pack arriving in the mail. Even if you do have to

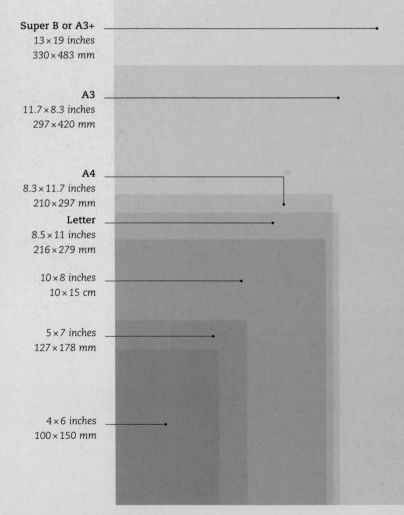

Super B or A3+
13 × 19 inches
330 × 483 mm

A3
11.7 × 8.3 inches
297 × 420 mm

A4
8.3 × 11.7 inches
210 × 297 mm

Letter
8.5 × 11 inches
216 × 279 mm

10 × 8 inches
10 × 15 cm

5 × 7 inches
127 × 178 mm

4 × 6 inches
100 × 150 mm

Relative Paper Sizes

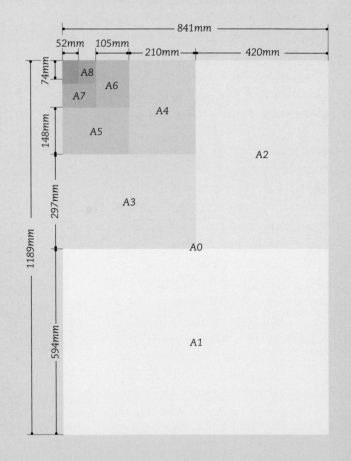

European "A" paper sizes—each numbered size is half the area (divided half way along the longest edge) of the previous one, from A0 downwards. The numbers here are shown in the center of their respective pages. A4 is the equivalent of Letter size, and A8 a business card.

pay, it's always cheaper than blindly buying a box of an unfamiliar paper that soon ends up filling shelf space and never gets used.

There are times when you take an instant liking to a paper and can justify the expense of a box of 50 or 100 sheets or more. A sensible first step is to buy a small pack with a few sheets of a size that you know you will use. Sometimes that can be as few as 10 sheets and of the smallest size, though generally the minimum quantity would be 25. By the time you've used that many sheets you should

The ANSI paper series more common in the United States follows a similar convention to the ISO "A" series, with Letter as "A" and Tabloid as "B." As on the ISO diagram, the letters are shown in the center of the page they represent—"E" is the whole diagram.

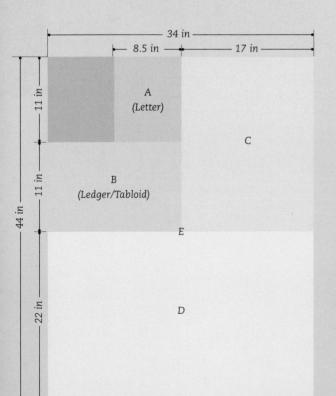

Printer and media sizes

Inkjet printers range from compact portable models for personal home use or on-site at events to the huge floor-standing wide-carriage models used in professional print studios. They are manufactured for worldwide use and therefore need to cover the variety of standard paper sizes, particularly the ISO and metric system used in most of the world as well as inches used in North America. Here's a look at the scale of things.

A6—105 × 148mm
Very close to 10 × 15cm or 6 × 4 inches. This is the smallest widely supported ISO A-size for photo paper.

10 × 15cm
This is the standard consumer print size, also referred to as the 6 × 4 inch print. There is a wide range of compact and portable printers dedicated to this print size. It is ideally matched to the frame aspect ratio of 35mm film and most DSLR camera image formats of 3:2.

5 × 7 inches
A very traditional print size that is now popular as a "super" standard alternative to the basic 6 × 4 inch print.

10 × 8 inches
This format is a hangover from the days of the darkroom and is not widely available in cut sheets, certainly not outside North America. The 10 × 8 inch size fits the aspect ratio of 5 × 4 inch film perfectly but is not well matched to the most widely used digital camera frame aspect ratios.

A4 210 × 297mm, or 8.3 × 11.7 inches
Very widely supported internationally as a photo paper size, its dimensions are 210 × 297mm, or 8.26 × 11.69 inches

A3 297 × 420mm, or 11.6 × 16.5 inches
This is a widely supported sheet size for inkjet photo papers, not to be confused with the larger A3+ size. Some earlier A3 printers will only accept this size of A3 paper, but all the latest A3 printers now usually accommodate A3+ as well.

A3+ 329 × 483mm, or 12.95 × 19 inches
This size is now widely supported as a standard cut-sheet photo-paper size and more closely matches the 3:2 aspect ratio of 35mm film and most DSLR camera frame formats than plain A3.

A2 420 × 594mm, or 16.53 × 23.38 inches
Supported by the Epson Stylus Pro 3800 and 4800 models, which can accommodate a maximum 17-inch paper width.

A2+ 431.8 × 609.6mm, or 17 × 24 inches (sometimes 17 × 25 inches)
This is another variation of the ISO A-standard, primarily for photo-printing use. Supported by the Epson Stylus Pro 3800 and 4800 models.

A1 594 × 841mm, or 23.38 × 33.11 inches
Requires a 24-inch wide printer like the Epson Stylus Pro 7450, 7800, 7880, 7900, or higher.

A1+ 610 × 914mm, or 24 × 35.8 inches
Requires a 24-inch wide printer, like the Epson Stylus Pro 7450, 7800, 7880, or higher. Closely matches the 3:2 aspect ratio of 35mm film and most DSLR camera frame formats than plain Tabloid (A3).

Although A0 and even A0+ sizes exist in the ISO specification, you would need the 64-inch width of an Epson Stylus Pro 11880 to accommodate such paper sizes.

Much above A2+ paper size, the sensible option is to use paper rolls rather than pre-cut sheets. Paper rolls are available in smaller sizes as well, and most Epson photo printers are supplied with roll holders.

the initial outlay can be worthwhile and roll paper can be an economical choice, especially if you print in large volume. You do lose the flexibility of being able to chop and change the type of paper you use, but in many cases that may be a minor sacrifice that is far outweighed by the convenience and print quality of consistently using a single paper.

Another reason for considering roll paper is for printing stitched panoramas. Photoshop's Photomerge and other stitching programs make it pretty easy to produce very large, high quality images from multiple frames, and there has been an explosion of interest in the panoramic format. Amazing though these monsters may be on the computer screen, it's a shame if something as trivial as paper width limits the size and resolution at which they are printed. Roll paper removes this issue.

have a good idea if it's the right paper for you, and it's then much less painful to order a larger box of the paper or to buy large sheets for bigger prints.

Roll paper

Similar considerations apply to buying paper on the roll as they do individual sheets. Once you are certain that you like a certain paper,

Epson supplies roll paper in widths as small as 4 inches (100mm) to 60 inches (1500mm), with a great many variations between. The roll lengths vary from around 16 feet to 100 feet (5 meters to 30 meters).

Many Epson photo printer models come supplied with roll holders, something which is unique to Epson in the non-professional end of the market. Printers with extra large carriages have the added advantage, when printing onto roll paper, of having a built-in paper cutter. This means that when you print on roll paper you can virtually eliminate waste as you simply separate one picture from the next, with no further trimming.

One issue to consider when using roll paper is that it will gain a natural curl and you may need to uncurl or flatten it after printing, which can sometimes be unwieldy. The problem is worse for smaller paper widths, especially when printed in volume and stacked, and can also be more troublesome near the end of the roll.

Finally, a good bit of practical advice is to ask around before buying a high end printer that takes roll paper. Sometimes the design is only really suitable for rolls, and while the printer can be loaded with cut sheets, others may have first-hand experience that doing so is rather awkward. For some users, that is not a problem as they are happy to stick to

roll paper, but others need a more flexible printing solution. Either way, it's best to know in advance.

Roll paper holders are optionally mounted at the back of a number of printer models.

Paper weights and thicknesses

While a picture may be beautifully presented on wafer-thin paper, a print is more likely to be appreciated if it is physically more substantial. To some extent, we are simply accustomed to associating a paper's quality with its weight, but it also indicates how well the paper is made and helps the printer transport a sheet and print onto it without any crumpling or slipping. In general, heavier paper is likely to be of a better quality, and some photographers find it a useful detail to include in their own sales information. Paper weight is, of course, only one indicator of quality.

GLOBALLY, PAPER WEIGHT, or density, is most commonly rated in terms of grams per square meter (gsm or g/m²), so a square meter of a paper such as Hahnemuhle Photo Rag Duo would weigh 308 grams and is specified as 308 gsm. It would, at first glance, be a higher quality paper than the same manufacturers' 160 gsm Allegretto.

In North America, the traditional rating method is different. The weight of paper is expressed as the weight, in pounds, of a ream of 500 sheets of the standard-cut base size of a paper. An example is for 20-pound bond paper. Its base size is 17 × 22 inches. From that four sheets of standard US letter size (8½ × 11 inch) paper can be cut. This means one ream of 20-pound letter size bond paper will weigh 5 pounds and each sheet will weigh 0.16 ounces, or about 75 gsm.

Paper weight and paper thickness often correspond, though it is not a simple relationship as some papers are denser than others. If the fiber base has been heavily compacted in the calendaring process, its density will be increased. Likewise, papers with thicker surface coatings will weigh more than those with thinner coatings.

Normally, resin coated glossy or semi-gloss inkjet papers should have a weight of at least 160 gsm in order to be robust and feel good in the hand. Fine art matte papers are usually best around the 250 gsm mark. The important thing is not to choose between papers by a crude comparison of their weight or thickness specifications, but by examining prints with your own eyes.

Texture

RESIN COATED PAPER SURFACES
The surface texture of a resin coated photo paper is determined by the way the paper is

Paper stiffness

Paper has to bend when it travels through the printer, and this can be a problem with heavier, stiffer papers. Most Epson inkjet printers offer a relatively relaxed paper path, so a sheet does not have to negotiate tight turns as it passes through the printer. But a particularly difficult paper may get jammed inside the printer or, more likely, emerge with scratch marks. In such cases, check the printer manual as there is a fair chance that it offers an alternative paper feed path for heavier papers and card.

Straight paper path

Textured paper can be thicker than its weight would suggest, as bumps and marks are elevated from the surface in either direction.

coated. The most common surface finishes are glossy and semi-glossy. The shine of glossy papers also varies from a dull gleam to an almost mirror-like nature depending on the brand.

Semi-gloss papers are more closely related to a luster or satin paper. Instead of a smooth shiny surface, microscopic dimples stipple the surface of the paper. The surface maintains a "glint" and the stipple can vary in coarseness, from very fine (satin or pearl) to medium (luster and semi-gloss).

MATTE PAPER TEXTURES
With the exception of specialist papers that have textured reliefs physically applied (like canvas effect, for example), the surface texture of a fiber-based paper is largely due to the fibers that make up the paper and the calendaring process to smooth the paper surface during the manufacturing process.

Surfaces can range from uniformly smooth to coarsely textured. Terms to grade these textures include words like "velvet," "silk," "smooth," etc. You may have to sample many different brands and styles before you find the formula that you prefer. Luckily, most fine art paper manufacturers have sample packs of their wares that, if not given away, aren't expensive to buy.

The American paper weight is typically expressed in terms of 2000 letter sized sheets, which is four stacks like these.

Permanence and longevity

Most photographers have experienced prints fading over time. Bright sunlight may bleach a print from your first inkjet printer, or a photolab print might discolor after being displayed on the fridge with magnets. Annoying though this may be, we almost expect this to occur to ordinary prints. But fine art prints can also degrade if they are mistreated and our expectations of longevity are higher.

MANY PHOTOGRAPHERS HAVE long-lasting darkroom prints (black and white, or Cibachrome), or early 1990s Fuji Velvia slides that retain their original colors, while Kodachrome transparencies are famous for looking as good now as they did decades ago.

When we are talking about print permanence, we are moving beyond such anecdotal evidence and into the realm of scientific research. Leading museums and galleries are anxious to safeguard their picture collections using the best, tested methods, and commission studies from academic and other professional bodies. One authority on the conservation of traditional and digital photographs is the Wilhelm Imaging Research, while there are

The US National Archive preserves important documents like the constitution at it's Washington DC home, but also has climate controlled facilities at locations including College Park, Maryland.

also international standards—ISO 18916:2007 on imaging materials is particularly relevant. However, while reports sometimes become widely available, they are not cheap and generally contain more supporting detail than most photographers need. The headline findings and summaries are often publicized, though, and are certainly worth reading and following up.

So, practically speaking, what are the top factors influencing image permanence?

Three key factors affect an inkjet print's life. The first two, the characteristics of the ink and the quality of the paper, need to be considered in combination. A failing in the one will render worthless whatever archival qualities the other may possess. The third—how the print is ultimately stored and displayed—can be altogether outside the photographer's control. After all, print permanence covers much longer time frames than our own lives.

Inks

Starting with inks, in the past it was possible to say that dye-based inks were unable to match the longevity of pigment-based inks. Being molecules dissolved in water, dye-based inks tended to fade more quickly than pigment-based inks, and they are more sensitive to damage from moisture and chemical vapors. Pigment-based inks are made of solid particles. While this can have disadvantages, such as a tendency to

Dye-based inks are considerably less able to withstand the ages than pigments, since they're solutions.

45

metamerism, pigment-based inks are more stable and hold their color while being less prone to light and chemical attack.

While this has been true, ink manufacturers have sought to address these issues, and Epson claims that "prints with Claria photographic ink and Epson Premium Glossy Photo Paper will last for 200 years when stored in an album." The observant reader will notice the precise wording and ask about the ink and paper combination's life when the prints are not stored in an album. That isn't stated.

Papers

Just as you can track down ink specifications, with a little effort you can find what inkjet paper vendors say about their products' expected lives. As a rule of thumb, the paper manufacturer will want you to know if a paper has archival properties, so permanence and longevity will feature prominently in marketing material and in the paper's detailed specifications. Indicators to look for include a paper being 100% cotton rag, and you would also expect such papers to be acid-free, buffered, and free of Optical Brightening Agents (OBAs).

Conversely, if the paper's specifications do not refer to such properties, you should not assume they are manufactured with archival permanence in mind.

Just as age affects inks, it also has an effect on paper. Over a period of years, low-grade papers will yellow and become brittle.

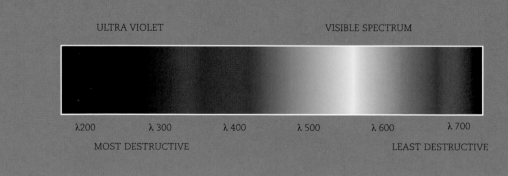

Light as a factor

Light falling on the print has a dramatic effect on its fading, and the more light the color inks absorb, the faster they will degrade. The shorter the wavelength of the light on the electromagnetic spectrum, the greater the destructive effect on the inks, so light that includes a greater degree of unfiltered UV, like sunlight, will have a more destructive effect.

ULTRA VIOLET VISIBLE SPECTRUM

λ 200 λ 300 λ 400 λ 500 λ 600 λ 700

MOST DESTRUCTIVE LEAST DESTRUCTIVE

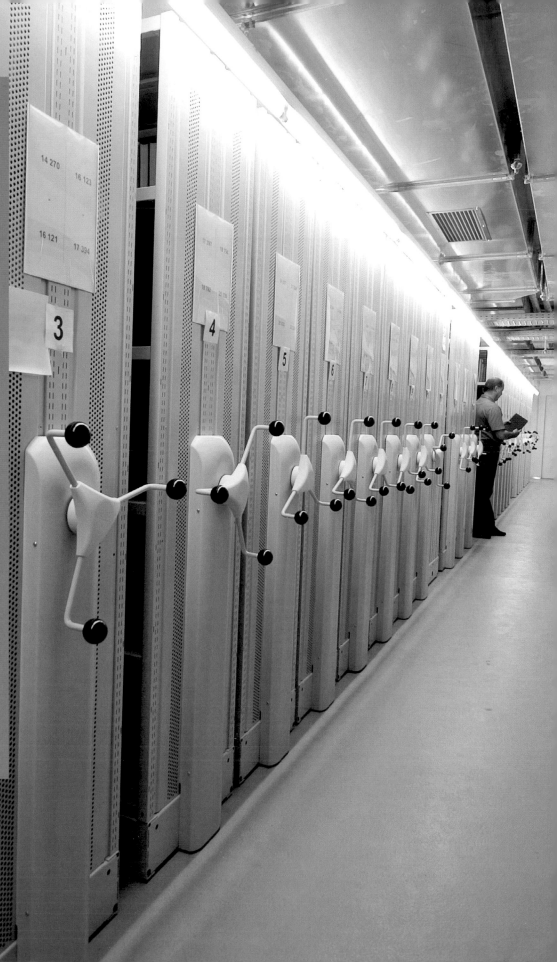

Environment

As much as you can choose a paper and ink combination for its longevity, there's also the third part of the trinity—how the print is kept afterwards. In many ways, this is the hardest thing to control. For instance, I recently heard of an unframed print which the owner had propped up with a plastic artificial flower—whose color promptly bled to the print. You simply cannot imagine how many environmental factors may shorten a print's life.

Equally, there's plenty you can do to maximize its chances. Keep prints out of the light, or frame them behind glass. Of course, while framing a print will reduce airflow and exposure to vapors, you also need to ensure that the mounting board and cut-out matte will share the prints' archival characteristics. As with ink and paper, manufacturers' specifications are available. The glass too should be free of potentially-damaging chemicals such as household cleaning fluids.

Prints should normally be stored in the dark, and in a dry and cool place with minimal humidity variations. General guidance is that the temperature should not exceed 20°C or 68°F, while relative humidity (RH) should not be above 30–40%.

Store prints flat and make sure that they are only in contact with individual envelopes and materials of similar archival standards. Eliminate risks, so there should be nothing like paper clips, rubber bands, Post-It notes, or sticky tape.

A last point is that, in order to have met the requirements of the International Organization for Standardization (ISO 18902:2001), specifically the Photographic Activity Test (ISO Standard 14523:1999), you must place all the prints in individual enclosures.

Archive facilities have no natural light, and a controlled temperature and humidity.

Paper handling

It obviously makes complete sense to keep unused paper in top condition before it passes through the inkjet printer. After all, it is not cheap, and a blank sheet can be degraded by most of the same factors that damage a finished print: light, chemical vapors, and physical mishandling.

Paper should be handled at the edges, not the printable surface. Note that this paper's curl places the printable side on the convex side of the sheet.

Storage of unused paper

Manufacturers supply paper in boxes or packaging designed to keep it in good condition until it is ready to be used. They almost always include instruction sheets with recommendations for the paper's use, most obviously settings for various printers or notes on drying fresh prints and their long term storage. Less obvious, but always there, is advice on the proper storage of paper before it is used. Almost always this amounts to a very simple precaution: keep the paper in the box or packaging in which it was supplied, and the box dry.

Its advice should be followed to the letter since it both reduces waste and maintains paper quality. For instance, I had opened 25 sheets of a silk-finish resin-coated paper and left the paper in its inner wrapper, a clear polythene envelope, not in the cardboard outer packaging. Though not in direct light, when I next wanted to use the paper I found that the top sheet had yellowed, and since the other sheets had fanned gently, each sheet had a similar patch along its exposed edge.

This sort of mistake can happen all too easily, and there's rarely a good reason to remove paper from its original packaging before it's needed.

Handling

While it might sound like recommending common sense, make sure your hands are clean when you are handling the paper, and hold it by its edges. I have even heard of some photographers who keep a pair of cotton gloves for handling paper, and while that may be overkill, it does emphasize the need for care. Fingers leave greasy marks on paper, and typically you won't notice them at the time but only later when the light

Tip box

If the paper is supplied in polythene packaging, watch out for the envelope's sticky patch, which can snag a sheet of paper as you take it out. One idea is to cut open the envelope carefully with a knife—just like using an envelope knife.

catches them from a different angle or when you're in a rush to deliver a job. If you do get greasy marks on a blank sheet, there's little you can do to remove them without potentially causing further problems. It's better to put the sheet aside and perhaps reserve it for test prints.

The printable side

With each paper you use, learn to recognize its printable side. The non-printable side is not designed to absorb ink and printing onto it will produce results which will be hard to explain away as anything other than a mistake. "Glossy" paper's printable side is indeed glossy, while you usually print on "silky" or "luster" paper's slightly-textured surface. Art papers often have a gentle curl and it's usually the concave side that is coated to receive ink. Although the difference between the printable and non-printable sides will often be obvious to the eye, the paper manufacturer's instructions usually provide guidance too.

Drying paper

As the fresh print emerges from the inkjet printer, it is perhaps at its most vulnerable to damage. While ink is manufactured so that it dries as it hits the paper, it is not absolutely dry at that point, and will continue to lose moisture for a few hours until it stabilizes and is completely fast. Until then, it can easily be ruined with a little carelessness.

Keep prints separate

Time pressures may often leave you no alternative to outputting pictures one after the other and letting the fresh prints stack up on the printer's output tray. That may be unavoidable, and should not generally result in a loss of print quality. All the same, on those occasions it's best not to interfere as the printer drops new prints on the stack—moving them might sometimes cause a smudge.

Where time is not so pressing, don't stack sheets until they are thoroughly dry. During that time, there's the risk of smudging the wet ink, or perhaps of airborne dust setting on the wet ink. Ideally, individual prints should be laid out separately for a few minutes after printing so that much of the remaining moisture can evaporate. Paper manufacturers often recommend a drying time, commonly 10-15 minutes, but this is not a hard and fast rule. It varies depending on the printer, the ink, and the paper stock, so make sure you review any drying

If paper is left in a stack, the surface of one sheet will be face to face with the backing of the next, potentially smearing ink and ruining prints.

A darkroom drying rack can be ideal for drying inkjet prints. Holding the paper vertically or at an angle, there's less risk of dust settling on the wet print.

This print drier is designed to dry prints quickly, but is only designed for drying resin-coated prints.

instructions. The environment also affects evaporation time, so it may be relatively short if the room is warm and dry, but the print will take longer to dry in lower temperatures or if it is humid or damp.

Drying racks

Drying prints should usually be kept out of direct sunlight and away from dust, and one good idea is to get yourself a drying rack. Originally intended for darkroom prints, simple drying racks are cheap and occupy much less space than prints laid out on a flat surface. Unless the paper has an exceptionally-strong curl, you can place lots of sheets on the rack and let the air circulate freely between them. A portable fan can increase the airflow and reduce drying time, but this should be done gently and should not risk moving the sheets.

More sophisticated drier units are available, some with heat settings and built in fans. However, they are usually expensive, and intended for specialist applications rather than for general user.

Leave it a few hours

In this part of the book we are mainly concerned with the paper's physical characteristics, and its storage and handling before and immediately after its use. However, while considering drying procedures, we should not overlook another benefit of letting prints dry properly before framing or delivering them, and that is as a precaution in case the print colors change as the paper dries out. This varies from paper to paper and has become less common as photo inkjet papers have developed, but it is still possible, and it makes sense to detect it sooner rather than later. It's an issue that we will examine in more detail later in this book.

Longer term storage

The key to good long term storage of prints is vigilance. We have already looked at the dangers that arise from a poor choice of paper and ink, but other risks come from where the prints are stored and how. The archives themselves need considerable care. While properly stored, prints can remain in top condition for many decades, but the risks need to be identified, assessed, and countered.

THESE DANGERS ARE very specific to where you live and work, and where you choose to store your prints. A photographer based in desert Arizona would probably face different challenges from one in humid Florida or another facing a Canadian winter. Apart from the weather, temperature, dust, or moisture, you've got to consider bugs, rodents, and mould, plus risks from household chemical vapors and water. The list is endless, and new, unanticipated risks often appear from nowhere, so you need to be proactive.

A great case study is this storage building, which a leading professional photographer recently constructed behind the family house in suburban London. It replaced an old wooden shed—one door is where the garden tools are now stored—and contains unsold limited edition prints, both traditional darkroom and inkjet prints, large numbers of negatives, backup hard drives and optical media, and some unused paper. The principal goal is to safeguard the long-term value of his work.

You need to assess the local risks applicable to your environment. In this case, southern England has a relatively mild climate, so there is less risk from prolonged periods of extreme heat or tropical humidity, and winters are less viciously cold than in other parts of the world. Dampness can be an issue, though, so the store was built with a ventilation unit designed to reduce condensation and mould, while extracting airborne dust and dirt.

The store was situated in a shaded area with good drainage. Its base is solid concrete and is covered with wood flooring, while the roof is slightly angled so rainwater flows straight off and will not penetrate the covering. Particular attention was also devoted to sealing the building and the roof, and excluding rats and other vermin.

We are also dealing with paper, which is potentially flammable, and a fire extinguisher is kept beside the garden tools. After consulting the print curator of a national photography museum, the print boxes were chosen for their archival specifications. All the boxes' panels are double-walled with the outside made of buckram, a cotton-based material, and the lining made of archival paper stock. They assemble without any adhesives or tape, seal tight, and are rigid and durable.

Another small point not to be overlooked is that if you can't find your prints when you actually need them, they may as well not exist. In this case, each box in this archive is numbered and can be cross-referenced to a handwritten inventory of its contents, though a digital database is also a possibility.

Avoiding complacency is integral to good archiving practice, and the inventory list had

This custom-built print store holds valuable traditional and inkjet prints in a temperature and humidity-controlled environment

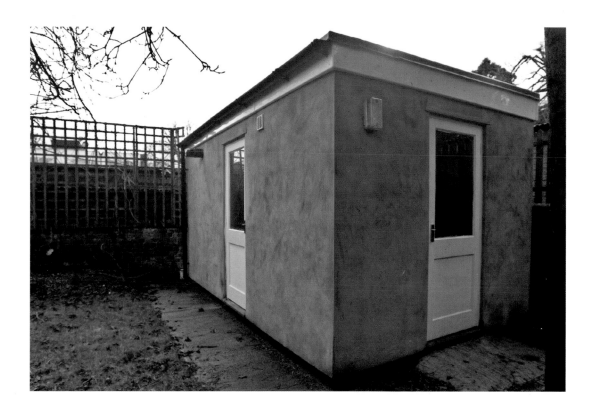

The humidity regulator also acts as a dust extractor and is cleaned as part of its service schedule.

Prints are stored in numbered archival-quality boxes, and kept off the ground.

recently been photocopied, so there was no longer just a single copy, and it was being duplicated onto a computer for added security and ease of searching. At the time of writing, a thermometer and hygrometer were on the photographer's shopping list. The key point is to keep questioning the archive's security, looking for potential weaknesses, and fixing them.

Lighting your workplace

One of the main causes of inconsistent output is reviewing fresh prints under varying light sources. While it's great if your workplace has a window allowing daylight in, even a relatively glare-free natural light's color changes throughout the day, as well as through the seasons, and you need to be sensitive to very subtle differences in print color.

You're not always going to apply the same fine judgement to one new print at midday and to another made later that afternoon when the sun is setting. One may look perfect, while the other may actually be too warm or cold, but your eye and mind are quietly compensating for the differences in the light source.

A picture being viewed in a desktop print viewing unit.

Of course, it's not just daylight that can mislead you. Household and office lights have a wide range of color temperatures, and this can be particularly noticeable with black and white pictures. An image may be printed with the latest inks, using accurate printer profiles, and may look perfectly neutral in daylight, but when it's viewed under a regular tungsten light, subtle greens or magentas may become visible, all because the grayscale tonality is built up with droplets of colored inks as well as the blacks and greys. You also have to consider other aspects of your surroundings—light bounces off walls, even your clothing—and the eye is such a wonderful thing that it corrects for such discrepancies without our noticing.

An economical way to eliminate inconsistency is with a daylight balanced lamp. One of the best known is the GrafiLite (see page 66) range, and smaller models take up little desk space while being suitable for viewing prints or color swatches. A viewing mat is also supplied, so your judgement is not affected by the table color.

More elaborate, wall-mounted print inspection stands are also available. Typically these come with side panels to eliminate the effect of other light sources, and some sort of mechanism such as rollers or a slot to hold the print without marking it. If you have the right skills, you can even make up such a viewing stand yourself—5000K daylight balanced light bulbs are widely available.

While it's ideal to examine prints with a daylight-balanced lamp or on a stand, it's also worth remembering that in the long run what's more important is where the print will actually be displayed. If a print is going to live its life in a room with tungsten lighting, examine it under similar light.

Desktop print viewing units
incorporate daylight-balanced
lamps and on the desktop and
really helps with soft proofing.

GTI Graphic Family

For larger prints, GTI Graphic
Technology are one of the leading
suppliers of desktop and wall
mounted print inspection
equipment. They have a range
of products to suit many sizes
of prints (www.gtilite.com).

SETTING UP YOUR COMPUTER

Color management

The need for color management starts to become obvious once you consider the number of devices that need to work together in an imaging system. The input might come from a digital camera, or perhaps a film scanner if our starting point is a negative or transparency, while a flatbed scanner would be needed for scanning in other artwork. Each has its own way of recording color as digital data.

TURNING TO OUTPUT devices, you may work on an image using an LCD or CRT screen whose colors differ, subtly or more, from the factory-defined specifications; someone may just have pressed the monitor's little buttons and the little shift to red went unnoticed. We're also dealing with light being emitted from the device. Equally two printers of the same model may remain within manufacturing tolerance yet output color different enough to be visible—and that's before we add to the mix the huge range of third party paper, even inks, which you might be using in your printer. Again, the printer has to process color data in its own way, and the final print will have its own color characteristics.

An imaging system almost inevitably includes a number of devices with differing technologies, different ways of assessing and managing color. So a Canon digital camera needs to sample the scene's colors and record them in red, green, and blue values, and in the format required by the camera's own operating system. The Epson inkjet printer also has its own proprietary operating system and ultimately needs to break down color information until it is able to send appropriate instructions to the ink nozzles. In other words, color is "device dependent."

Stuck in the middle of all these devices, somehow your computer needs to reconcile all this device dependant color. As if it wasn't challenging enough to carry the original scene's colors all the way through to the final print, the computer needs to deal with many permutations of input and output. The final image may consist of a digital photograph plus artwork that has been scanned or created in a drawing package such as Adobe Illustrator. As well as merging multiple inputs, the output may well be destined for multiple devices. You might want to print using more than one printer, or perhaps display it on an electronic picture frame, not to mention the web and PDF.

What is needed is a way to move the color information through the various devices in an accurate, predictable, and efficient way—a Color Management System. This can be broken down into two key requirements; the first of which is a color space that is device-independent—the "Working color space." The second is a way to accurately describe the color characteristics of each camera, printer, scanner, monitor, and so on—the ICC profiles. The third is a means of exploiting profiles so that each device's color information (the device-dependant color) can be translated through the system.

Many have already offered varies analogies for color management—that it's like a chain, or perhaps building blocks. Personally I prefer to think of it as stepping stones, all of which are necessary to place your foot on accurately to make it across.

You can shoot and store a picture on an Epson camera and output it onto an Epson printer using Epson inks and paper, yet such closed systems are better in theory than in practice.

Epson digital camera

P7000 portable hard drive

Outside the loop

Stepping away from the closed loop, there are even more opportunities for color confusion, If you have a camera from one manufacturer and a printer from another (not to mention a computer graphics card and a computer display somewhere along the line) then there are certain to be further difficulties.

Typical digital SLR

A scanner

Color spaces and gamuts

An ICC color profile is a file that describes a particular device's color characteristics and how it captures or outputs color values. They are often known as ICC profiles after the International Color Consortium (http://www.color.org/), the industry body that creates, promotes, and standardizes the vendor-neutral, cross-platform, color management architecture and components.

THERE ARE THREE main types of ICC profile: input, display, and output.

Input profiles are for input devices such as cameras or scanners, which capture color, the first step in the process. To produce an input device profile requires accurate information about the real color of the original object—this means the use of a reference target of known colors against which the capture's RGB values can be modeled. Profiles for scanners are common, as they are self-contained units with their own light sources, but it's less common to profile cameras because lighting conditions vary. The profile would only tell you what the camera's color characteristics are in those lighting conditions. Unless you can repeat them, for instance in a studio, camera profiles have little value.

Display profiles are for computer monitors or TV screens, while output profiles are for printers, from desktop inkjets to commercial offset and digital presses. As we will see on the following pages, these profiles are created by measuring the device's output—the monitor or the print—against known values. Monitor profiling has been a do-it-yourself task for a few years, while printer profiling is still on a twin track. Custom color profiles are available from vendors or remote profiling services, or you can make your own if you can justify the cost of the equipment needed.

With each device having a profile, things take shape. Photoshop or other ICC-aware imaging software can control colors by reading any profile already embedded in the image. It can read the monitor profile and understand what colors you are seeing on screen. When you tell it you are going to print the image on your Epson 2880 using Premium Luster 260, the printer profile gives it the information to convert the image's color data into the instructions needed by the printer.

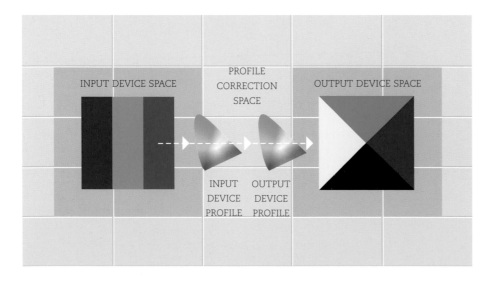

INPUT DEVICE SPACE

PROFILE CORRECTION SPACE

OUTPUT DEVICE SPACE

INPUT DEVICE PROFILE OUTPUT DEVICE PROFILE

Color management is about taking color data from one device to another—from an RGB capture to an inkjet printer with any number of inks.

Management approach

Remember my stepping stones analogy. With color management you're jumping between irregular objects and can easily slip. But you can see where you're going and with a bit of care you can get there.

A color chart, printed so devices can be tested against its purity.

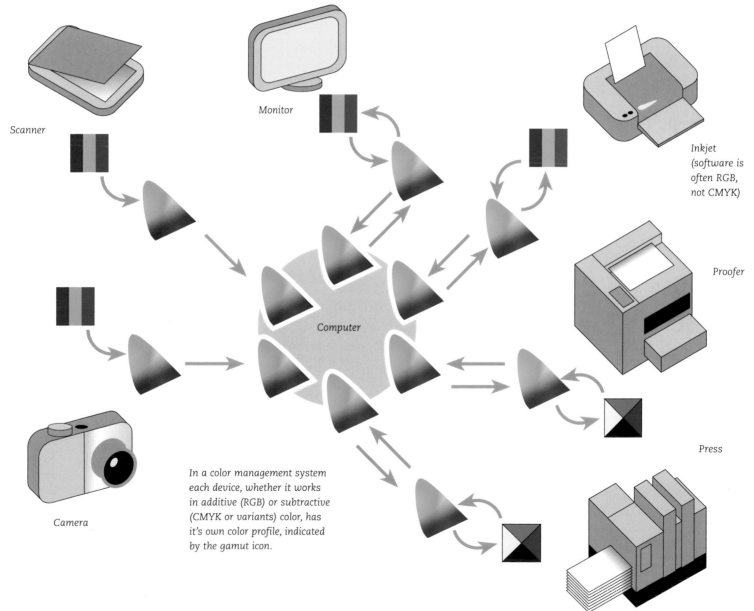

Scanner

Monitor

Inkjet (software is often RGB, not CMYK)

Proofer

Press

Camera

Computer

In a color management system each device, whether it works in additive (RGB) or subtractive (CMYK or variants) color, has it's own color profile, indicated by the gamut icon.

Monitor calibration

The single most important step in color management is calibrating your monitor. If the computer doesn't know how it is displaying the colors that you are seeing, it's going to have a hard job translating them into accurate instructions for the printer. Both the Mac and Windows operating systems now include color calibration utilities that allow you to calibrate the display with your own eyes, but for a more dependable scientific approach you really need to consider a colorimeter.

Monitor calibration devices like this one need to be rested against the screen. Once in place, the software will commence showing it a series of colors.

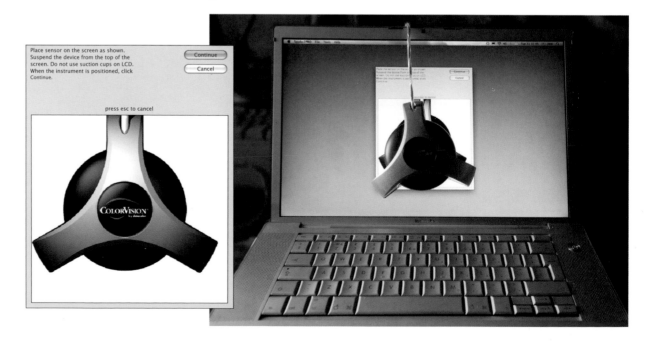

Current Settings

To adjust the display to the settings shown below, mark the appropriate radio button and click the right arrow to continue.
To change the settings, mark the appropriate radio button and click the right arrow to continue.
For a complete explanation, click the Help button.

Display type: LCD
Display: 1–Color LCD

Gamma: 2.2
White Point: Native

Luminance Mode: Visual
Black Luminance: na
White Luminance: na

Last Calibrated: 14:03 2/11/07
Current Profile: Color LCD Calibrated 071102.icc

○ Continue with these settings
○ Change these settings

Help
Back Next

A screen from the ColorVision calibration software. As you can see, the device keeps you informed about the settings you're using.

Calibration

Serious photographers budget for devices such as the Eye-One Display from Gretag Macbeth, the Spyder, or the more recent ColorMunki. These combine a colorimeter with dedicated software. Whichever model you choose, the color consistency of your prints will show a marked improvement.

Before beginning calibration, allow the display to warm up. A screen's color characteristics are not always the same when it is cold, and it should be allowed to settle at its working temperature.

Another preparatory step is to disable any screen savers or energy management settings on the computer, because you don't want them to kick in while the colorimeter is doing its calibration work. It is equally important to keep the screen away from

lamps or windows, and it's a good idea to switch off lights and perhaps close the blinds.

In general, all these devices give you a series of on-screen instructions, that need to be followed. Usually you are told to place the colorimeter on your monitor and then the software sends a series of test colors to the screen. The device measures how the monitor is outputting these colors and, after 5-10 minutes, creates a color profile.

Next steps

Most calibration devices automatically save the new monitor profile in the correct folder for Mac or Windows and also set it as the current profile. The next step is to use the profile in Photoshop or other imaging software. Your photos should already look more accurate on screen.

Post-calibration

After you have calibrated the monitor the first time, it's a process that should be repeated every so often. Each time you change the monitor's settings, you will probably remember to recalibrate, but you may not be aware if someone else alters the brightness when you are absent. The monitor's performance characteristics may also change over a period of time, or occasionally a color-managed program may suddenly start displaying weird colors—a sign of a corrupt monitor profile. To deal with such eventualities, some photographers recalibrate their monitors every month. You can ask your computer to remind you to do so. It's a quick job and soon becomes a habit.

Printer profiles

With your monitor calibrated, the color management chain is nearly complete. Your computer has the right information to assess the image's on-screen appearance, and it is ready to translate it into instructions to send on to your inkjet printer. It just needs to know a little bit more about the intended output. While the computer usually detects the printer model and the cartridges, printers aren't smart enough to establish what type of paper you are using, and in any case, both printer and ink may vary from factory settings. What it needs is a definition of the characteristics of your combination of printer, ink, and paper—a printer profile.

ESSENTIALLY YOU HAVE a couple of choices. One is to obtain printer profiles from Epson, a third party ink or paper vendor, or from a remote profiling service. The other is to build your own custom profiles.

Epson profiles

At first, it is sensible to keep things simple and stick to Epson inks and paper. The printer's setup disc will install Epson's ready-created profiles on your system, and updated profiles can also be found on Epson's support web site. These are usually a good starting point.

Third party papers and inks

Third party vendors obviously want to make using their papers and inks as easy as using Epson's own products, so the manufacturers or distributors usually supply printer profiles at no extra cost, typically as downloads. Again, these generic profiles are often all you need to start getting great results.

Custom profiling services

Most printer, paper, and ink combinations will be covered by Epson or third party profiles, but it is quite possible that you may discover

A set of tables ready to be sent to a remote profiling service.

an exception, or perhaps be dissatisfied with a supplied profile's results. One course of action is to buy your own spectrometer (see "Colorimeter profiling" on page 66) and make your own printer profiles. Often, however, a more economical solution is to find a remote profiling service, which will create a profile just for you.

The process is quick and simple. Some third party paper or ink suppliers offer custom profiles for free, or you can consult a professional printing and color management specialist. In each case, you are generally given instructions and a target file that you put through your printer with the ink and paper combination that you want to profile. You then mail the print to the vendor or profiler, and they use a high quality spectrometer to create a unique ICC profile for your printing environment. This is normally emailed back to you with installation instructions.

Where to install printer profiles

Mac OSX – HD › User › Library › ColorSync › Profiles

Windows XP and Vista – C:/windows/system32/spool/driver/color

On Windows XP and Vista, monitor and printer profiles go in C:/windows/system32/spool/driver/color.

On the Macintosh, the profiles are installed into the Library, within the Profiles folder of the ColorSync area.

On Windows or Mac computers you can get information about any profile by simply right clicking it (if you're using a one button mouse with a Mac, Ctrl-click). This is a paper profile supplied by the paper supplier Permajet for one of its inkjet papers.

1	A1			
2	A2	0.00		
3	A3	0.00	0.00	
4	A4	0.00	32.00	0.00
5	A5	0.00	64.00	0.00
6	A6	0.00	96.00	0.00
7	A7	0.00	128.00	0.00
8	A8	0.00	160.00	0.00
9	A9	0.00	192.00	0.00
10	A10	0.00	224.00	0.00
11	A11	0.00	255.00	0.00
12	A12	0.00	0.00	0.00
13	A13	0.00	32.00	32.00
14	A14	0.00	64.00	32.00
15	A15	0.00	96.00	32.00
16	A16	0.00	128.00	32.00
17	A17	0.00	160.00	32.00
18	A18	0.00	192.00	32.00
19	A19	0.00	224.00	32.00
20	A20	0.00	255.00	32.00
21	A21	0.00	0.00	32.00
22	A22	0.00	32.00	64.00
23	A23	0.00	64.00	64.00
24	A24	0.00	96.00	64.00
25	A25	0.00	128.00	64.00
26	A26	0.00	160.00	64.00
27	A27	0.00	192.00	64.00
28	A28	0.00	224.00	64.00
29	A29	32.00	255.00	64.00
30	A30	32.00	0.00	64.00
31	A31	32.00	32.00	0.00
32	A32	32.00	64.00	0.00
33	A33	32.00	96.00	0.00
	B1	32.00	128.00	0.00
	B2	32.00	160.00	0.00
	B3	32.00	192.00	0.00
			224.00	0.00
			255.00	0.00

An ICC color profile contains a series of measurement tables like this.

Colorimeter profiling

Making your own printer profile is not difficult, but until recently the cost has been a big deterrent. While a monitor calibration device can cost less than a hard drive, the equipment for creating your own printer profiles has cost four or five times as much. However, the success of the ColorMunki, a dual device combining monitor and printer profiling, has been as much due to its lower price as to its features, and this seems to indicate that printer profiling will soon become almost as common as monitor calibration—which will be no bad thing.

A WIDE RANGE of products is available from color management specialists like Color Confidence, who make the ColorMunki, Gretag-Macbeth, Pantone, or Chromix. Some products are very expensive, partly because they are pitched at press and other commercial-scale printing environments, but even those suitable to home or small office inkjet printers will set you back enough to merit a cost-benefit comparison.

Unfortunately, before making the investment, such an analysis can only be approximate. You may be able, for instance, to cost the time you save getting prints that match your quality standards, and paper and ink wastage may well come down dramatically, especially if you use a variety of third party paper and ink combinations. Yet precise numbers, if ever possible or truly accurate, will only be available in retrospect, and in any case it can be difficult to place a value on greater dependability of output. How do you ever evaluate the psychological benefits of printing becoming a more reliable experience? All one can say is that you need to go through this thought process for yourself and for your individual circumstances. While making your own printer profiles can, for some, amount to a question of whether you can afford it, others would ask how a professional setup can afford not to do so?

This spectrophotometer is a dual purpose device for monitor and printer profiling. It measures the full visible spectrum of light reflected from color prints or screens.

While individual profiling products differ in many ways, in general they all come with hardware devices and supporting software for both Mac OS and Windows. You are then guided through the process with on-screen instructions, and this usually means printing a sample page using your chosen combination of printer, ink, and paper.

Often a specially-defined grid of colored cells or tiles, you allow the sheet 10-15 minutes' drying time and then follow the instructions and roll the spectrophotometer over each row in turn. Sometimes a further sample page is needed, so the device can measure other hues. As soon as that's done, the software generates the printer profile and places it in the correct folder for your operating system.

Photoshop color settings

Now we turn to setting up your image editing software for a color-managed workflow. With your monitor properly calibrated, and printer profiles representing possible combinations of printer, ink, and paper, your computer now has the key information about the hardware you're using. Image editing software can get the monitor's profile from the operating system, and translate the on-screen image into a print. It just needs you to choose a printer profile and tell it which printer, ink, and paper you're using.

PHOTOSHOP

NOT SO LONG ago, a book such as this would have shown Adobe Photoshop's color management and only mentioned other image editing programs in passing. But Photoshop's status as most photographers' main printing application has been challenged—or rather complemented—by Adobe's own Lightroom and Apple's Aperture. I say "complemented" because many photographers do more complex image editing in Photoshop but use Lightroom or Aperture to manage their pictures. If you do manage images with these programs it makes sense to print directly from them when you need another copy of an image.

Whichever program you are using, it's important to understand where its color management settings are and how to use them. So we will look first at Photoshop which—given it's broader user base and legacy—has many more options, and then we'll examine the more streamlined color management features of Lightroom and Aperture.

Photoshop's color settings

Under Photoshop's Edit menu is the Color Settings command. This very important dialog box is where you set the working color space—the profile Photoshop will use to manage color—and in particular the Working RGB (the theoretical color space that you are using while editing). You need to choose a setting that provides the best image quality for inkjet printing. It is also where you decide how Photoshop should handle any differences between your chosen color space and whatever profile may already be embedded in an image.

The Color Settings dialog box caters to Photoshop's very wide range of users, not just inkjet photo printers. Web designers often work in the sRGB color space, while commercial press operations focus more on CMYK settings—to mention just two groups of users. So rather than explaining all Photoshop's settings, the following pages will concentrate on getting the color settings right for inkjet photo printing.

APERTURE

Settings

Depending on your location, the default setting is either North America General Purpose 2 or Europe General Purpose 2. For inkjet printing it's better to change this to US or Europe Prepress Defaults, but that is only a starting point.

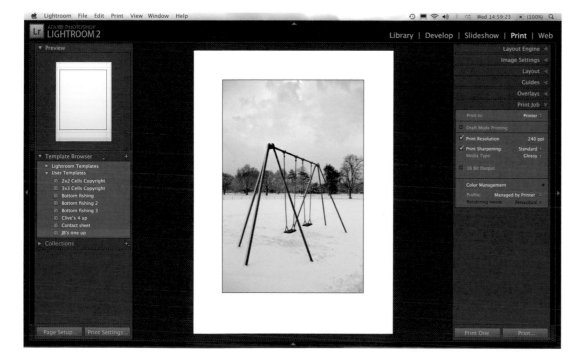

LIGHTROOM

Adobe Photoshop, Adobe Lightroom, and Apple's Aperture are three of the most popular choices for editing and printing photographs, with the latter two handling image management too.

Photoshop detects when an image's embedded profile doesn't match your chosen color space.

Color Management Policies

Color Management Policies comes next and this is where you tell Photoshop how it should deal with any clash between its settings and those that may already be embedded in an image. Perhaps you have files "tagged" with different profiles, before you started a color-managed workflow, or a picture may have come from another computer with different color settings.

For example, imagine Color Settings shows the Working RGB is set to the sRGB. What should Photoshop do if you then open an image whose profile was the much wider ProPhotoRGB working space? Should it convert the colors to sRGB? Equally, consider a second case where Photoshop has been set to work in ProPhotoRGB and the image is a JPEG straight from the camera and tagged as the narrow sRGB. Should Photoshop convert the image data to the wider working space, or works with it as it is?

The drop-down box's choices are quite straightforward:

- Off
- Convert to Working RGB
- Preserve Embedded Profiles

Working Spaces

Working Spaces is a key group of settings, and you have separate drop-down boxes for RGB, CMYK, Grayscale, and Spot. These correspond to the color modes used in Photoshop's *Image › Mode* menu. We only really need to set the RGB color setting:

- **Adobe RGB** is a general purpose color space and has a wide gamut (range of colors). It may appear the obvious choice, but it's not really the best.

- **sRGB** This is a very common color space because of its use for the web and for JPEGs. It also has the narrowest gamut of color, so you shouldn't choose it if you want the best print quality.

Notice the Description area at the bottom of the Color Settings dialog. As you move the mouse over drop-down menus and other parts of the dialog there's a short, but often helpful, explanation of the settings. Here the More Options button in the top-right group is selected.

- **ProPhotoRGB** is another, more modern general purpose color space, and it has the widest gamut of colors. For this reason it's now generally acknowledged as the best color space to choose for inkjet photo printing. Unless you have a specific reason to the contrary, choose ProPhotoRGB.

Off turns off color management for new Photoshop documents and for files whose profile differs from the Photoshop's working space. It's not a good choice if you are trying to establish a color-managed workflow.

Convert to Working RGB assumes that the working RGB should take priority over any profile that may already be in the image. In the first example above, this choice would convert my wide gamut ProPhotoRGB file into the narrower gamut sRGB. That might suit someone producing images for a internet site, because sRGB is the lowest common denominator, which ensures that images look OK in whatever browser is being used to view them. For the inkjet printer, however, the conversion would effectively discard a lot of subtle colors and image quality. So it's not the ideal choice.

But, in the second case, where Photoshop is set to ProPhotoRGB, converting an sRGB-tagged JPEG to the wider gamut Working RGB would not do the image any harm and would potentially allow you to do more work on it without posterization or other damage. If you are routinely working with JPEGs or images with a narrower profile than ProPhotoRGB, the choice of Convert to Working RGB may be appropriate.

Preserve Embedded Profiles means that Photoshop respects any profile embedded in the image. When you open an image whose profile differs from the Working RGB, Photoshop does not convert the colors but leaves things how they are.

So the ProPhotoRGB image would be opened as ProPhotoRGB, even if Photoshop's Working RGB were sRGB. Equally, the JPEG is opened as an sRGB image and not converted to the wider gamut Working RGB.

While this seems a somewhat passive approach, it's actually the choice that leaves you the most flexibility, does no damage, and doesn't stop you changing the color space afterwards. That is why, on balance, it is the best choice here.

Also in Color Management Policies is a small group of check boxes called Color Mismatches. These settings are less critical in terms of getting color right, but are valuable as they allow you to balance smoothness of workflow against knowing how Photoshop is handling mismatches.

Essentially the check boxes tell Photoshop whether to prompt you for a decision when you open a file whose profile differs from Photoshop's Working RGB.

When you're first getting used to a color-managed workflow, it can be a good idea to leave all these settings checked. Each time Photoshop finds a mismatch, it will ask you what to do—use the embedded profile, convert it to the Working RGB, or switch off color management. The great thing is that it forces you to go through the thought process each time.

However, it can be tiresome if Photoshop has already been set to respect any embedded profiles. Also, after a short while, you'll be confident of what Photoshop is doing. So once you reach that point, uncheck them.

This gamut comparison shows the ProPhotoRGB space in cyan, the sRGB space in magenta and the Adobe RGB space in yellow.

There is a serious risk of a clash between printer and printer-software managing the colors and Photoshop trying to do so. As the reminder shows here, only one device should do so at at time.

Saving Files

One important concept is that Photoshop has document-specific color settings. The Working Space chosen in the Color Settings dialog is for Photoshop's overall environment. It will be used for:

• New documents
• Existing images with no embedded ICC profile
• Imported untagged images such as those from digital cameras.

When you save a file, the color space is embedded inside it.

Here one image is ProPhotoRGB, another Adobe RGB (a mono one, at that) and another uses sRGB—this is document-specific color at work; all three can be open at once.

Document specific color means that each individual file has its own ICC profile embedded within the document. While Photoshop itself has an overall color space, it can have open a number of images, each using its own color settings.

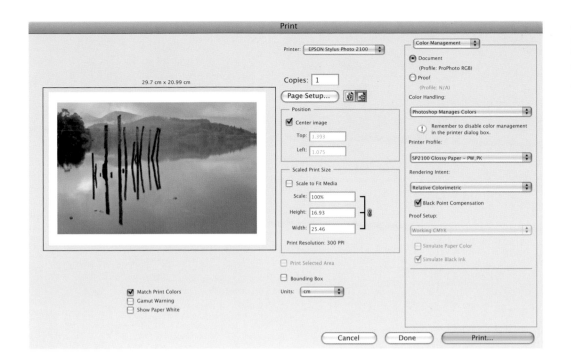

Photoshop's *File > Print* dialog box is where all the color management work comes together. The preview can be in soft proofing mode, via the Match Print Colors check box, and other settings control print scaling and color handling.

Printing

The *File > Print* dialog box is another critically-important area of color management in Photoshop. This is where everything comes together—the calibration of our screen, the printer profiles that describe the characteristics of the printer, ink, and paper that you are using, not to mention the original image's aesthetic quality and post processing work.

Assuming you have got everything right so far, this is about the last point where it's possible to take a wrong turn.

Fortunately, a lot of work has gone into making the choices as obvious as possible, and—since Photoshop CS3—the Print Preview dialog box has been color managed and even has soft-proofing built-in.

The color management section is on the right-hand side of the window where there is a drop-down box with two choices. One is Output, but for now choose Color

Management, and you get a number of settings which, not surprisingly, are best understood by working from top to bottom.

By default, Photoshop assumes we want to print using the image or "document" profile. The next setting, Color Handling, is much more critical and gives us four choices:

• **Printer Manages Colors** Photoshop lets the printer convert colors from the document to the printer's internal color space. Choose this option when you don't have profiles for your printer, paper, and ink combination.
• **Photoshop Manages Colors** Photoshop converts the colors and sends them to the printer. This is the choice you must use when you are printing profile tests.
• **Separations** is for printing CMYK separated colors, unimportant here.
• **No Color Management** is not recommended when printing pictures.

The first two are the important ones for our needs, so let's look at each in turn.

The Color Handling drop-down box lets you decide whether Photoshop or the printer should manage the colors.

Print

Printer: EPSON Stylus Photo 2100

29.7 cm x 20.99 cm

Copies: 1

Page Setup...

Position

☑ Center image

Top: 1.393

Left: 1.075

Scaled Print Size

☐ Scale to Fit Media

Scale: 100%

Height: 16.93

Width: 25.46

Print Resolution: 300 PPI

☐ Print Selected Area

☐ Bounding Box

Units: cm

☐ Match Print Colors
☐ Gamut Warning
☐ Show Paper White

Cancel

APJ_OEM2100PK_Delta_WCRW_#1
ARRIFLEX D–20 Daylight Log (by Adobe)
ARRIFLEX D–20 Tungsten Log (by Adobe)
CIE RGB
Color LCD
Color LCD Calibrated
Color LCD Calibrated 071102
Color LCD Calibrated 090210
Dalsa Origin Tungsten Lin (by Adobe)
e–sRGB
Fujifilm ETERNA 250 Printing Density (by Adobe)
Fujifilm ETERNA 250D Printing Density (by Adobe)
Fujifilm ETERNA 400 Printing Density (by Adobe)
Fujifilm ETERNA 500 Printing Density (by Adobe)
Fujifilm F–125 Printing Density (by Adobe)
Fujifilm F–64D Printing Density (by Adobe)
Fujifilm REALA 500D Printing Density (by Adobe)
Generic RGB Profile
HDTV (Rec. 709)
John's Spyder 071102
Kodak 5205/7205 Printing Density (by Adobe)
Kodak 5218/7218 Printing Density (by Adobe)
Kodak 5229/7229 Printing Density (by Adobe)
Nikon Adobe RGB 4.0.0.3000
Nikon AdobeWide RGB 4.0.0.3000
Nikon Apple RGB 4.0.0.3000
Nikon Bruce RGB 4.0.0.3000
Nikon CIE RGB 4.0.0.3000
Nikon ColorMatch RGB 4.0.0.3000
Nikon D1 for NEF v.1.0.0.3002
Nikon DBase for NEF v.3.0.0.3001
Nikon MacMonitor RGB 4.0.0.3000
Nikon NTSC RGB 4.0.0.3000
Nikon sRGB 4.0.0.3001
Nikon WinMonitor 4.0.0.3000
NTSC (1953)
PAL/SECAM
Panavision Genesis Tungsten Log (by Adobe)
ROMMI–RGB
SDTV NTSC
SDTV PAL
SMPTE–C
SP2100 Archival Matte_MK
SP2100 Archival Matte_PK
SP2100 Glossy Paper – PW_PK
SP2100 Premium Semigloss_PK
SP2100 Standard_MK
SP2100 Standard_PK
SP2100 Watercolor – RW_MK
SP2100 Watercolor – RW_PK
Spyder Calibrated 090210
Viper FilmStream Daylight Log (by Adobe)
Viper FilmStream Tungsten Log (by Adobe)
Wide Gamut RGB

Euroscale Coated v2
Euroscale Uncoated v2
Generic CMYK Profile
Nikon CMYK 4.0.0.3000
Photoshop 4 Default CMYK
Photoshop 5 Default CMYK

Black & White
Generic Gray Profile
NikonGrayG1.8 v4.0.0.3000
NikonGrayG2.2 v4.0.0.3000
sGray

Printer Profile is where you tell Photoshop exactly what the printer, ink, and paper combination you are using.

Photoshop Manages Colors

For our purposes, the most likely choice is Photoshop Manages Colors. Also known as application color management, this method is designed for the color-managed workflow where the user wants complete control of how document colors are rendered. Photoshop converts the colors and sends the instructions to the printer driver.

Notice that choosing Photoshop Manages Colors immediately makes available the Printer Profile drop-down box. This is because Photoshop Manages Colors means that you are telling Photoshop to convert the image colors and to do so using the profile selected in the Printer Profile drop-down box.

Remember I mentioned wrong turns? Well, one is here. It is very easy—even for experienced inkjet printer users—to overlook that the Printer Profile drop-down box defaults to the current Working RGB. At this point Photoshop has no real idea what paper the printer is using. Almost always, the Printer Profile needs to be changed to the profile that represents the printer, paper, and ink combination you are using. Even if you haven't changed anything, always review the Printer Profile setting before you click the Print button.

Once a printer profile is selected, both Rendering Intent and Black Point Compensation (BPC) are activated. Generally you'll want to use Perceptual or Relative Colorimetric and have BPC checked. It's worth noting that with many of the newer models from Epson it is probable that choosing Relative Colorimetric will produce the more pleasing prints.

Printer Manages Colors

The other important Color Handling choice to try is Printer Manages Colors. This makes Photoshop leave the document color management entirely to the printer driver, so Photoshop does not convert the document colors or pay attention to whatever paper and ink settings may be in the printer driver. The document is sent directly to the printer driver with tags on how to convert its colors, but it is the printer driver that attempts to obtain accurate print color.

Experienced inkjet printer users who have their own print profiling equipment are often able to get better results by creating their own print profiles for Epson papers. So they, like authors of Photoshop books and tutorials, tend to prefer the Photoshop Manages Colors route.

Too many cooks spoil the broth

Another very important point is that the printer's own color management must be switched off in the printer driver. You don't want the printer fighting Photoshop.

When Photoshop's managing the colors, switch OFF the printer driver's color management.

However, Printer Manages Colors is certainly worth trying. You would usually choose it in two circumstances:
• You are using Epson paper and Epson ink and get good results.
• If you don't have a profile for the printer, ink, and paper combination.

While Epson's own profiles can be bettered, it's clearly in Epson's interests to support its printers with profiles that let the user get the most out of Epson papers and inks. So Epson continues to improve the accuracy of its supplied profiles and drivers, and updates are available on Epson's web site (www.epson.com). Printer Manages Colors can produce great results.

Sometimes you don't have a profile for a third party paper, and pretending it is another paper hasn't produced results quite as beautiful as you had hoped. In this case Printer Manages Colors allows you to access the printer driver and, using an existing Epson paper as a starting point, adjust how the printer outputs colors.

Getting into the printer driver is a bit awkward and varies a little depending on software version and operating system. On Windows the easiest way is to click the Page Setup button in Photoshop's *File > Print* dialog. That should take you to your printer's properties dialog box, which is actually the driver. Enter Custom mode, and click the Advanced button.

Under Color Management, the No Color Adjustment option should not be set—doing so would turn off the printer driver's color handling and is exactly the opposite of what Printer Manages Colors is supposed to do. Instead, choose Color Controls.

On a Mac, I find the easiest way is to click the Print button in Photoshop's *File > Print* dialog. Choose Color Management from the drop-down box, click the little triangle next to Advanced, and the dialog box reveals a series of sliders.

Both Windows and Mac users can then adjust these sliders to tweak the color output and run a test print. If your eyes tell you that your paper needs less magenta or more green, drag the corresponding slider and then run another a test print. You're moving boldly into the realm of guesswork and experimentation.

Epson's printer driver lets you start from a supplied paper profile and tweak the color output. On Windows the printer driver looks different, but has similar controls.

Visualizing Color spaces

Because the scientific L*a*b color system used to describe color spaces has three axes, it can be hard to visualize. In this book there are traditional illustrations (see page 71) since these clearly indicate the scope of different spaces, but to get the full picture you will need to use a program like ProfileEditor, which can produce 2D and 3D comparisons of color spaces. You can move the view in three dimensions by dragging with your mouse, and the free demo mode will allow you to try the experience (www.xrite.com).

Rendering intent

While a color management system can accurately describe input and output device's color reproduction, that isn't the whole story. The reason these systems exist is because every device is different and one cannot display the same range of colors as another. In digital printing, the issue is that the printer's gamut—even that of modern multi-ink printers—is generally significantly narrower than an RGB monitor. There are a number of options when compensating for this.

THESE OPTIONS ARE known as the "Rendering intent," a concept encountered on page 75, and they allow you to specify whether your computer should attempt to compensate for the printer's gamut automatically, or simply print the colors that work as best it can and ignore the fact that some fall out of gamut.

Rendering intent, however, can also be part of the color workflow when you import your pictures from your camera or other device to your computer, especially if you have them set up in different color spaces. You can set Photoshop's default rendering intent in the Color Preferences dialog introduced on page 70, the same dialog where you set up your working profile.

As you might imagine, the best results when printing photographs are achieved by using a rendering intent designed to achieve continuous graduation of tones in the resulting prints. This is what the Perceptual option is for. The compromise is that not only the colors out of gamut need to shift, but all shades are also adjusted proportionally so that detail can be rendered in out-of-gamut areas. This is a compromise, but one well suited to photographic prints. Indeed it can be fairly likened to chemical processes since these too were proportionate rather than 100% accurate.

That said, it is not always a compromise you need to make. If your image consists only of in-gamut shades, then there is no need to sacrifice the accuracy of Relative Colorimetric, and you can safely select this. Using the soft proofing tools to make a decsion will help you decide whether you should go for the accuracy of the Relative Colorimetric mode or the safety of Perceptual.

Where rendering intent happens

The rendering intent choice is applied both when a file is converted into the working space, and when it is output to your printer. It is this latter occasion which garners more attention, since the printer's gamut is likely the smallest of those involved so there is more potential for loss in the translation.

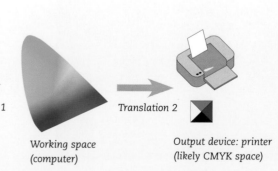

Translation 1 *Translation 2*

Input device: RGB digital camera *Working space (computer)* *Output device: printer (likely CMYK space)*

In a Relative Colorimetric conversion, the shades that are outside the gamut area are clipped and, rendered as the nearest in-gamut color. The result is areas of continuous tone in the print where there were areas of detail in the source.

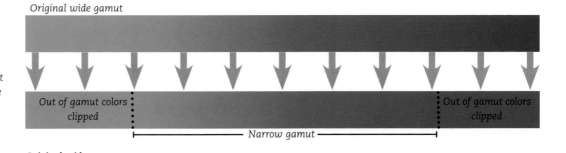

With Perceptual rendering intent, all of the shades are adjusted so that they fit proportionally inside the narrower gamut, meaning that all the detail is preserved, but at the expense of color accuracy.

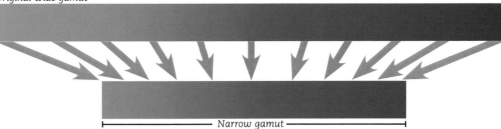

Saturation Intent preserves the strongest possible conversions of fully saturated colors. It's most useful when converting to a wider color space (the opposite of the scenario in the perceptual intent conversion) than the starting one, so those bright shades will be brighter still. This has more to do with display graphics than printed ones; for example converting from a web graphic to a known monitor. It's not really suited to photos.

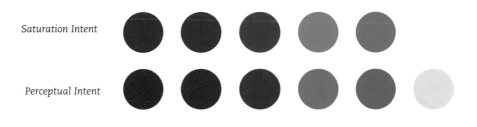

In a color space there is a line between black and white known as the white point. This gamut chart, which is a section half way from the brightest and the darkest points shows the two different mid grays, but it's important to remember that this is merely one layer of a 3D-structure, with darker shades lower and lighter shades higher (see page 77). At the top is the white point.

In an Absoloute Colorimetric conversion, the white point is preserved, while in a Relative Colorimetric conversion the other colors are adjusted to compensate. Absolute can lead to color shifts similar to the effects of incorrect white balance settings, while Relative compensates for characteristics of the target (off-white paper, for example).

The original color space is in black, the target in yellow, and their white points marked.

In Absoloute Colorimetric, the white point is preserved in the same location in the new space.

In Relative Colorimetric, the colors are proportionately shifted to the new space's white point.

Soft proofing

In an ideal world, the print would come out of the printer looking just like it does on your computer screen. Unfortunately, it is not quite so easy because we are dealing with a series of devices and materials, and the monitor may have non-standard settings, as may the printer, the ink, or the paper. As we have seen, calibrating the monitor is the essential first step, and then a good profile for the printer, paper, and ink combination should get us close to good, predictable results.

EVEN THEN, THE print may still not match the screen. It may then be tempting to apply a bit of guesswork and adjust the image so that although it looks wrong on screen, you're pretty sure the print will now come out right. For instance, if the prints are generally too dark, you might lighten the picture in Photoshop so that the end result is acceptable. But it's not a very satisfying method, and a rather hit or miss affair. That's where "soft proofing" comes into its own.

Soft proofing is a feature of Photoshop and other imaging software where the picture is displayed as it should appear on the print. By choosing the printer profile, the user tells Photoshop the exact combination of printer, paper, and ink that will be used to output the print. When the user then enters soft proofing mode, the software then applies the profile's information and adjusts the image's on-screen appearance. In other words, it's a clever kind of "print preview."

It should be said that for the soft proofed image to be of use, there must be accurate profiles for both the monitor and the printer. If the screen is not properly calibrated, or the output device's profile is inaccurate, Photoshop will not be able to make the on-screen preview look like the print.

View	Window	Help
Proof Setup		▶
✓ Proof Colors		⌘Y
✓ Gamut Warning		⇧⌘Y
Pixel Aspect Ratio		▶
Pixel Aspect Ratio Correction		
32–bit Preview Options…		
Zoom In		⌘+
Zoom Out		⌘–
Fit on Screen		⌘0
Actual Pixels		⌘1
Print Size		
Screen Mode		▶
✓ Extras		⌘H
Show		▶
Rulers		⌘R
Snap		⇧⌘;
Snap To		▶
Lock Guides		⌥⌘;
Clear Guides		
New Guide…		
Lock Slices		
Clear Slices		

Ctrl/⌘+Y switches soft proofing on and off. Switch on Gamut Warning with Shift+Ctrl/⌘+Y.

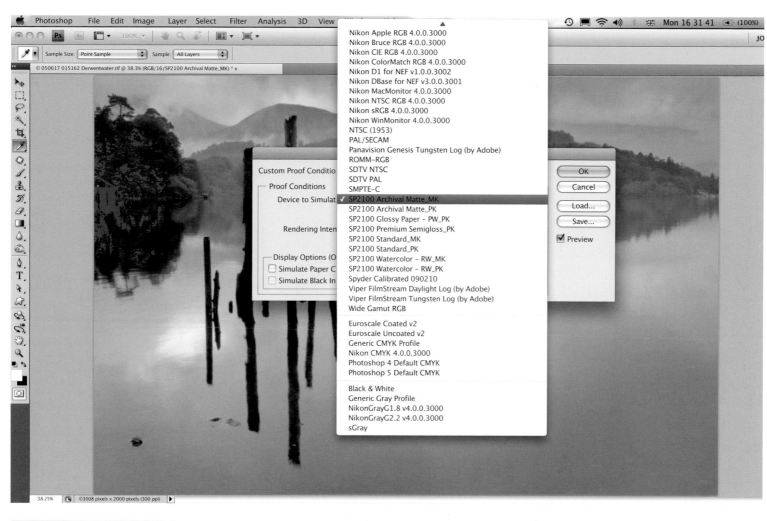

Proof Setup allows you to
choose the profile representing
the printer, paper, and ink
combination you want
Photoshop's soft proofing
to simulate.

What to do about it

What soft proofing often reveals is that the paper and ink cannot reproduce as wide a range or gamut of colors as the monitor can display. You then have to decide what, if anything, to do about it.

Once you know you have a problem, one approach is to adjust the image until the on-screen colors lie within the printer's gamut. Switch on Photoshop's Gamut Warning with Shift+Ctrl/⌘+Y and any colors that lie outside the printer's gamut will be highlighted. You can then adjust the picture with a Saturation or Curves adjustment layer and bring its colors back within gamut. Unfortunately, while this gamut-based method tells you whether the colors will be printable, it doesn't tell you how they will appear and can still lead to wasted prints.

The other method is to create a copy of the image file and arrange both copies on screen. One, the master file, is left untouched and shows how the picture should ideally appear.

I like my Gamut Warning to be nice and brutal, but you can adjust it in Photoshop's Preferences—it's under Transparency and Gamut.

When you switch on the Gamut Warning, Photoshop highlights out-of-gamut areas. Notice that the document's title area also shows the printer profile that it is currently being simulated—in this case a third party paper type.

Let's look at the steps

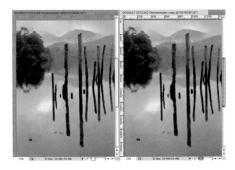

1 Choose *Image › Duplicate.* It can be a good idea to give the copy a name such as "Soft Proof Copy."

2 Select *Window › Arrange › Tile* so that the two copies are side by side.

The copy is viewed in soft proofing mode, and you add adjustments until it looks as close to the master reference image as it can.

The process is not exact, but generally the print will be a much better image with the adjustments made while soft proofing. As a final step, I like to bundle all the Adjustment Layers into a Layer Set named so I can remember the adjustments' purpose. I then drag it over to the master image and switch off its visibility, saving the master file and discarding the copy.

A couple of other settings are worth mentioning. Simulate Black Ink is usually left checked so the soft proof display lets you evaluate the print's color gamut.

© 050617 015162 Derwentwater.tif @ 38.3% (RGB/16/SP2100 Archival Matte_MK) *

3 Click on the original image's name to activate it, and make sure Proof Colors is off.

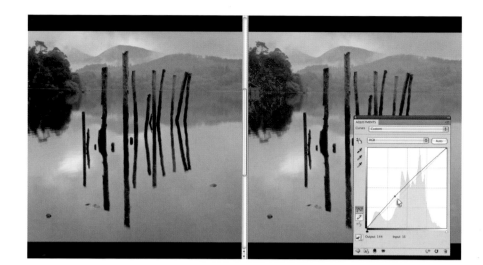

5 Add adjustment layers, either via the icon in the Layers palette or via *Layer › New Adjustment Layer*, and adjust the "Soft Proof Copy" until its appearance matches the reference image. The most likely adjustments are Hue/Saturation, Levels, and Curves. Also pay attention to the adjustment layer's blending mode—setting it to Color will ensure that the adjustment only affects the image color and not brightness.

4 Activate "Soft Proof Copy" and switch Proof Colors on.

Simulate Paper Color can be left on or off. Switched on, and you can assess the print's dynamic range on-screen, but it will look washed out because the whites will no longer be as bright as your monitor can display. At first, this can be misleading, and leaving Simulate Paper Color turned off will usually be easier until you have experience of how the on-screen appearance translates into the results on paper.

Soft proofing can simulate the paper's color. The left half is how the picture is supposed to look, while on the right the whites are subdued, indicating that they won't look as bright when printed as on screen. You might want to apply a brightness adjustment layer to compensate for subdued whites on paper.

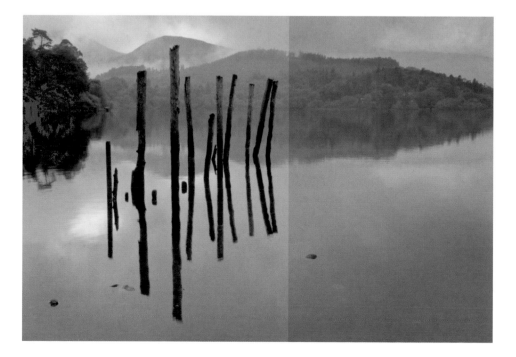

Software setup and resolution

Before we can make a print of the size we want, we need to translate the digital image's pixels to paper's inches or centimeters. The image's height and width may be 3872 × 2592 pixels, 4208 × 2800, and so on, but the same pixels could be squeezed into a 5 × 7-inch print or stretched out to poster size. The resolution—how many dots are printed per inch—is the missing link. Put it another way: printed size (inches) × resolution (dpi) = image pixels.

Photoshop's Print dialog has a setting that's useful for quick resizing but not if you are seeking the finest quality.

OVER THE YEARS Photoshop's Print dialog has developed into a powerful tool and has combined into a single interface with other functions such as a soft proofed preview, borders, and resizing the image to fit the chosen paper size. Handy though this is, it doesn't offer the same level of control as resizing the image before entering the Print dialog. If you use advanced sharpening methods, for instance, resizing through the Print dialog reduces the size of any sharpening haloes and so softens the image. It's much better to set the print size through *Image > Image Size* and then set the appropriate sharpening.

Photoshop users who also use Lightroom or Aperture have another option—printing their PSD and TIFF files through those programs. This can save lots of time printing batches of images or printing different sizes from the same master file, and avoids any risk of flattening complex, multi-layer Photoshop files and losing the original data.

The *Image > Image Size* dialog is not that difficult to master. Look first at the Resample Image setting. If this is ticked, changing the pixels dimensions, document size, or resolution will mean that the actual image pixels will be changed or "resampled." If it is not checked, changes to the document dimensions or resolution will not affect the image pixels. The option to choose depends on what you are doing.

For example, if you are printing a JPEG it may well have a resolution of 72dpi. That's fine for viewing on screen, but not at all suitable for quality printing—it would be a big, low resolution image. A 36 × 53 inch (91 × 135 cm) print would look fine if viewed from a distance, but not if you expect it to be viewed from close up. 300dpi would be a better choice for a normal size print, but you wouldn't want to change the actual pixels—you're only correcting the resolution at which they are output. So in this case you would uncheck Resample.

Image Size

Pixel Dimensions: 37.7M (was 57.4M)

Width: 2100 pixels

Height: 3137 pixels

OK
Cancel
Auto...

Document Size:

Width: 7 inches

Height: 10.457 inches

Resolution: 300 pixels/inch

☐ Scale Styles
☑ Constrain Proportions
☑ Resample Image:
Bicubic (best for smooth gradients)

On the other hand, let's say you want to print a 3872 × 2592 pixel image and the resolution is already set at 300dpi for a normal print quality. Left these settings as they are, the picture would print out at 12.9 × 8.6 inches (36 × 22 cm). But if you wanted a 10.5 × 7 inch (27 × 18 cm) print, for instance, you would get better results by resampling the pixels and then applying the appropriate level of print or output sharpening. So leave Resample checked, set the dimensions in the Document Size, and then click OK.

☑
☑

Nearest Neighbor (preserve hard edges)
Bilinear
✓ Bicubic (best for smooth gradients)
Bicubic Smoother (best for enlargement)
Bicubic Sharper (best for reduction)

Resampling means Photoshop has to recalculate and interpolate the pixel data, and you can choose from alternative methods at the bottom of the Image Size dialog. If you are making the image bigger, choose Bicubic Smoother. If you are reducing the image size, pick Bicubic Sharper and the resized image will keep more detail and appear sharper.

Saving the image as a "smart object" layer means that you can resize the file but the original image data is preserved, side-stepping the detail loss inherent in resampling multiple times.

LAYERS

Normal Opacity: 100%

Lock: ☐ ✎ ✛ 🔒 Fill: 100%

👁 Edge burning

👁 Darkening fields

👁 060531_034643 Swaledale

Printing with Aperture

Apple's Aperture was the first of that new wave of database-powered image editing programs that combined catalog functions with the ability to make most of the image adjustments photographers need to make. The goal is a more streamlined workflow, so Aperture can take pictures off the camera, adjust them, and print them. Even if a picture needs a quick trip to Photoshop for extra adjustments, you can then come back to Aperture for printing.

AS A NEW program for photographers, Aperture doesn't offer all the different color management and printing choices that Photoshop provides. Like Adobe's Lightroom, it doesn't need to allow for old ways of working or for an enormously wide range of users. So there is no equivalent to Photoshop's Color Settings dialog, no choice of Working RGB. The Mac operating system provides the color management, Aperture uses its own internal profile, and soft proofing is built into the *File > Print* dialog box. Some may regard this lack of choice as dumbing-down, but when all you want to do is print your photos, you don't need irrelevant, confusing choices. It's all about best practice, and including only those features that a photographer actually needs.

At the bottom of the View menu, you have two commands—Onscreen Proofing, which switches soft proofing on, and *View > Proofing Profile*, which is where you tell Aperture what kind of paper you want it to simulate. As you choose different papers, Aperture updates full screen images (not the thumbnails) to give you an idea of how the image will appear on paper.

File > Print initiates Aperture's printing process and displays a three-column dialog box. The first column, Presets, lets you store frequently-used settings and recall them with a single click. So you can instantly switch to your settings for printing with

You can switch on Aperture's soft proofing by selecting Onscreen Proofing at the bottom of the View menu, and change the profile via the Proofing Profile option beneath it.

Hide Toolbar	⇧T
Customize Toolbar...	
Highlight Hot & Cold Areas	⌥⇧H
Quick Preview	P
Onscreen Proofing	⌥⇧P
Proofing Profile	▶

Nikon NTSC RGB 4.0.0.3000
Nikon WinMonitor 4.0.0.3000
Nikon sRGB 4.0.0.3001
PAL/SECAM
ProPhotoRGB
SMPTE-C
SP2100 Archival Matte_MK
SP2100 Archival Matte_PK
✓ SP2100 Glossy Paper – PW_PK
SP2100 Premium Semigloss_PK
SP2100 Standard_MK
SP2100 Standard_PK
SP2100 Watercolor – RW_MK

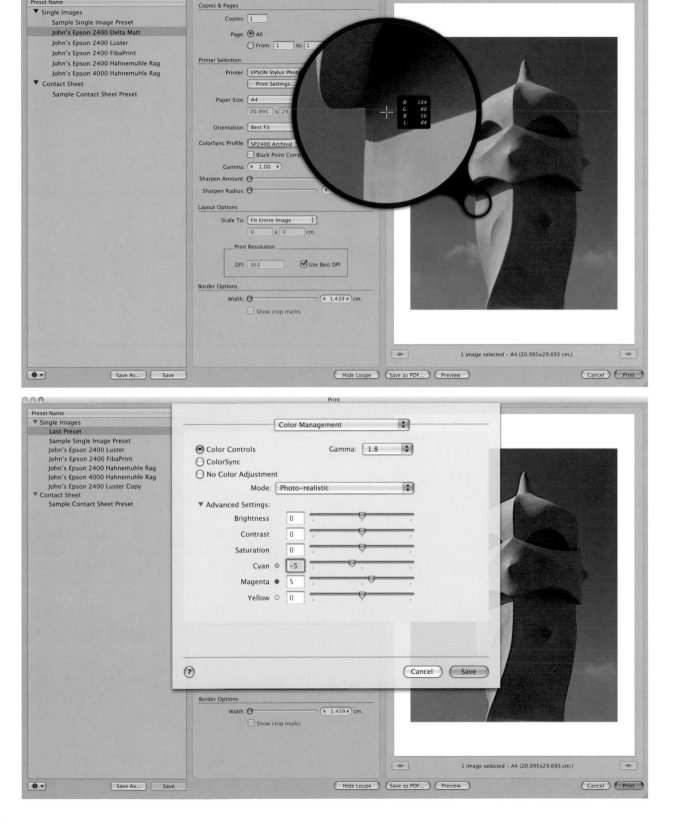

Aperture's File > Print dialog has three columns; presets for your favorite print setups, the middle column with the various print options, and on the right a soft proofed preview.

Click the Print Settings button and you can get to your printer's driver settings if you want advanced control over its color output.

87

System Managed

Output Profiles
APJ_OEM2100PK_Delta_WCRW_#1
Black & White
Euroscale Coated v2
Euroscale Uncoated v2
Generic CMYK Profile

✓ SP2400 Archival Matte_MK
SP2400 Archival Matte_PK
SP2400 Glossy Paper – PW_PK
SP2400 Premium Semigloss_PK
SP2400 Standard_MK
SP2400 Standard_PK
SP2400 Watercolor – RW_MK
SP2400 Watercolor – RW_PK

U.S. Sheetfed Coated v2
U.S. Sheetfed Uncoated v2
U.S. Web Coated (SWOP) v2

Other Device Profiles
Black & White
Blue Tone
Generic Lab Profile

A little further down, the really important setting is ColorSync Profiles. This is where you choose the printer profile appropriate for the printer, paper, and ink combination you are using. Especially interesting is that when you choose a profile, Aperture updates the print preview at the right—the Print dialog box is effectively soft proofing.

There are also settings for print orientation, size, and borders, but the last controls I want to highlight are the two sliders for print sharpening. These are what is often called "output sharpening," which is purely applied while printing to tweak the image for the chosen size of print.

Aperture shows the results of sharpening in the Print dialog's preview. Handy though this is, it is worth making the point that this preview is only an on-screen simulation, and the monitor has a much lower resolution than the print. It is not the same as examining the print itself and then considering whether just enough sharpening has been applied—but not so much that it is noticeable. In other words, regardless of the on-screen preview, it is something of a leap of faith.

I like to use Aperture's Loupe to zoom in on the Print dialog box's preview and see the results of sharpening in greater detail. Activate the Loupe using the Show Loupe button or by using the keyboard shortcut ~ (tilde). Then move the cursor to a critical area of the image—eyes for example—and fix the Loupe to that spot by using the keyboard shortcut Shift + ~ (tilde). You can now adjust the sharpening sliders and see their effect on key details.

a certain sharpening level, a 1.57 inch (4 cm) white border on Epson Premium Luster, on an Epson 2400. It's a good idea to name your presets systematically so it's easy to recognize what they do; I use printer model then paper name.

The middle column is where you choose how to print. Some of the settings are self-explanatory, but one of the important ones is found just under where you choose the printer. It's a button called Print Settings and provides access to the Epson printer driver. Switch it to Color Management and click the triangle next to the word Advanced, and you are given access color sliders so you can tweak the output. This can be useful if you don't have a good profile for the paper you are using.

Finally, let's return to the Presets in the Print dialog's left hand column. When you've just spent a few minutes getting the settings just

Print	
Copies & Pages	
Copies:	1
Pages:	⊙ All
	○ From: 1
Printer Selection	
Printer:	EPSON Stylus
	Print Settin
Paper Size:	A4
	20.995 x 29
Orientation:	Best Fit
ColorSync Profile:	SP2100 Standard_MK
	☑ Black Point Compensa
Gamma:	◀ 1.00 ▶
Sharpen Amount:	◀ 0.72 ▶
Sharpen Radius:	◀ 5.09 ▶
Layout Options	
Scale To:	Fit Entire Image
	0 x 0 cm.
Print Resolution	
DPI: 363	☑ Use Best DPI
Border Options	
Width:	◀ 1.439 ▶ cm.
	☐ Show crop marks

R: 210
G: 187
B: 149
L: 189

The Loupe previews the results of Aperture's output sharpening, but always base your sharpening on the final printed output.

right, it makes sense to save a preset so that next time you print it'll be a breeze to repeat those settings. The more efficient you are with routine tasks, the more time and energy you have for the much more interesting artistic ones!

Printing with Lightroom

YOU INITIATE PRINTING by going into Lightroom's Print workspace. On the left are templates where you save favorite print settings and recall them when needed. You also have direct access to Lightroom's "collections," which serve as virtual folders and help you organize your pictures.

To the right are a number of panels such as borders, orientation, or add a title. These options are pretty self-explanatory, so let's go straight to those important for accurate, consistent color.

Shortly after Aperture was released, Adobe responded with Lightroom and offered versions for both Mac OS *and* Windows. It shares Aperture's objective of streamlining the image editing process and eliminating unnecessary options, so Lightroom uses its own wide gamut color space and gives the user no control over it. At the time of writing, Lightroom 2 does not have any soft proofing features. This omission, perhaps a tacit acknowledgement that only a small "elite" soft proof, means that printing in Lightroom is very straightforward indeed.

Many photographers begin editing pictures in Lightroom, do additional detailed work in Photoshop, and then return to Lightroom for its slick printing interface.

Template Browser — +

▶ Lightroom Templates
▼ User Templates
　　2x2 Cells Copyright
　　4x5 Contact Sheet
　　5x8 Contact Sheet
　　Fine Art Matt
　　Maximize Size
　　Clive's 4 up
　　Contact sheet with pseudo ratings
　　John's one

Save your settings as templates—you'll save yourself a lot of time if you do so.

Image Settings ▽

☐ Zoom to Fill
☑ Rotate to Fit
☐ Repeat One Photo per Page
☑ Stroke Border
　　Width ——————— 1.0 pt

The right panel contains a range of helpful layout settings.

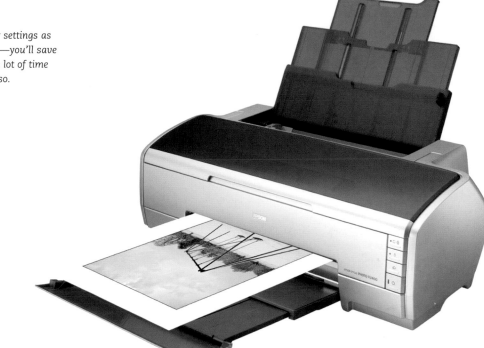

At the bottom of the left panel are two buttons. Page Setup is where you can choose paper size, while Print Settings accesses the printer driver. However, the really important settings are in the Print Job panel at the bottom of the right panel. Print Sharpening gives you three straight choices of output sharpening—Low, Standard, or High—and does not output a potentially misleading preview. You should examine the print, not the monitor's preview, and then decide if the sharpening level is suitable to the image. Generally, the setting should be left at Standard, while Low and High are best reserved for images with special requirements. For instance, a portrait of a child may well look best with only a small amount of sharpening.

There's also a setting for 16-bit output. If your printer has 16-bit printing, it's worth trying and placing 8-bit and 16-bit prints side by side. In theory there should be smoother

tones, but it will be interesting—impressive, even—if you can spot the difference.

Next is the critically-important Color Management setting, and Lightroom defaults to Managed by Printer. Leaving it set to this option will mean that the printer driver controls the output, so you have to make sure you set the correct paper choice either in Print Settings or after you press Print.

However, Lightroom was born in the era of ICC profiles, and the Color Management drop-down box also lists all the print profiles on your computer. Choose one of these, hit Print, and switch off the printer driver's Color Management in the Printer's own dialog.

Until Lightroom includes soft proofing, there's not a lot more to be said about setting it up for printing. But that's the idea—it's intended to be that straightforward and it certainly manages it.

Color Management ◀

Profile:　　Managed by Printer ⬍
Rendering Intent:　Perceptual ⬍

Managed by Printer is a good choice when you're using Epson's own paper.

Managed by Printer

APJ OEM2100PK_Delta_WCRW_#1
SP 2400 Archival Matte_ML
SP 2400 Archival Matte_PK
SP 2400 GLossy Paper – PW_PK
SP 2400 Premium Semmigloss_PK
✓ SP 2400 Standard_MK
SP 2400 Standard_PK
SP 2400 Watercolor–RW_MK
SP 2400 Watercolor – RW_PK

Other...

The Color Management drop-down box also lists all the print profiles on your computer.

8-Color hi-fi process

One of the amazing things about the devlopment of inkjet printing has been the speed and flexibility that new inks were added to the process, allowing ever wider gamuts to be represented on the page. The following section of this book also uses an extended gamut to give the best possible comparison of the included pictures.

The picture on page 104 as separated into eight colors (note that the orange, green, violet, and gray inks are simulated using CMYK here).

MANY PROFESSIONAL PRINTING houses use carefully calibrated Epson printers with multiple inks as their proofing systems—as indeed we did in the production of this book—but when they're looking at printing beyond the gamut of CMYK on their presses, (known as a high fidelity, or "hi-fi" color) then they turn to a piece of software called ICISS, from experts Specialcolor (www.specialcolor.com).

This tool allows the user to specify any color inks, and any number of inks, to be used in printing an image. The only necessity is that the print operator can source them, so Pantone numbered shades are used (the recognized standard for colors in printing). For this chapter we've selected a green, an orange, and a violet ink because they all extend the CMYK gamut in the directions it is weakest, as well as a mid-gray which, like those used on Epson printers, has the effect of softening the halftones to effectively increasing the apparent resolution.

Although we're using it to provide the best possible reproduction of the originals and scanned prints in the comparison section, ICISS is popular both with fine art printers where the need for quality outweighs the economies of the traditional 4-color process, and with textile and T-shirt printers, where there is less potential for halftoning so extra colors increase the design's impact. Packaging, too, is an area where additional (or fewer) inks might be used by designers looking, for example, to maximize the impact of a brand's color (color shades have become

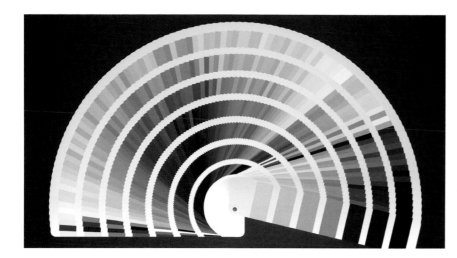

The Pantone color swatch has a vast range of shades from which any can be selected to use as an ink. We chose four in addition to the CMYK used throughout this book.

Channels

Once processed by the ICISS software, the image is split into (in this case) eight channels The images are saved as DCS files, which supports spot colors. The ICISS Photoshop plugin allows you to view the spot colors in the main Photoshop window, making the process much easier, even for less experienced designers.

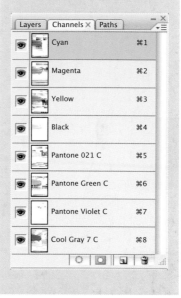

so important that it is possible to trademark a color within a specific field).

The ICISS system is not the only way of reproducing additional colors. As we've already mentioned, many printers, including those from Epson and Canon, include extra ink shades (Epson uses orange and green in its UltraChrome HDR printers, and Canon use red and green in its 9000 series printers). In the professional field, Pantone—the company responsible for swatches of standardized ink colors—developed a

6-ink system called Hexachrome. It too uses green and orange in addition to the traditional cyan, magenta, yellow, and key (black) inks. Hexachrome has got off to a slow start thanks to the need for special software, Pantone's licensing fees, and the proliferation of 4-color presses. However, Photoshop started to include support for multichannel processes in CS4, so it's possible that we'll see more multi-color professional printing in the future. In the meantime, it's a great way to see the best in our test prints.

Print comparisons

Understanding how your printer processes colors will help you appreciate the joys of printing with any of the modern ink systems found in Epson printers, as well as the potential pitfalls. Over the following pages a series of different images have been reproduced using the hi-fi color process described on page 94 and also an Epson printer.

In addition to the whole-image comparisons, detailed panels show the effect of zooming in on certain areas of the image. Their individual captions indicate what point is being illustrated, but it is important to remember that all of these are presented at larger than actual size, exaggerating any imperfections and making individual ink droplets visible when they might not otherwise be. Additionally, the Epson prints have not been made at the maximum resolution, since the process of color creation through dithering is our interest here.

OBVIOUSLY THE TECHNICAL limitations of the printing process mean that the Epson results are then scanned and printed using the same inks, but the breadth of the hi-fi process used should provide the best possible printed comparison between the systems.

Because this page is printed using the standard 4-color process, and the facing page begins the 8-color section of this book, this gives us the additional opportunity to show the same image printed using the standard CMYK inks used throughout this book and in most standard book, newspaper, and magazine processes.

DETAIL
The off-white license plate is a good test of how accurate the gray shading is in a print system.

CMYK VERSION

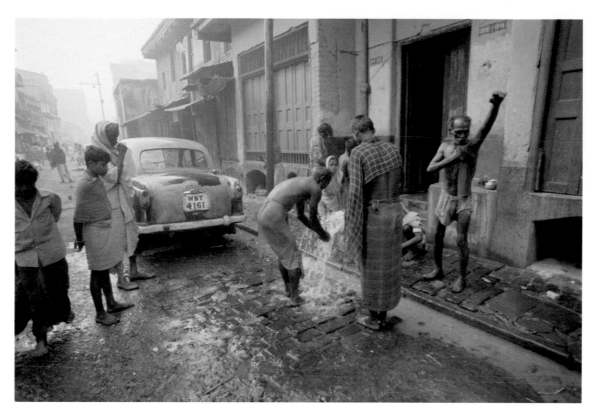

HI-FI COLOR VERSION

EPSON PRINTED VERSION (ULTRACHOME K3)

A subtly shaded picture is a challenge for any color printing system, which must use halftoning or dithering to achieve the same result.

DETAIL
In this hi-fi color version of a shot largely within CMYK gamut, lighter areas look better.

DETAIL
Even gray areas such as this feature a number of other shades, like the Light Cyan ink.

HI-FI COLOR VERSION

This picture has a great deal of subtle variations in shade, and benefits from a printer with a light black ink system. The ripples in the water call for a clear, sharp, high resolution print so that the eye can clearly distinguish between the peaks and troughs. An additional challenge is the almost monochromatic quality of the picture as a whole, which is largely in shades of brown. The narrow range calls for very accurate printing.

DETAIL 1
The dark skin tones are a challenging mix of shades where detail is crucial.

DETAIL 2
The light area on the back of the boat is essentially a shaded gray tone, so in a 4-color system more halftoning would be visible.

EPSON PRINTED VERSION (ULTRACHOME K3)

DETAIL 1
In the Epson printout the magenta and yellow inks stand out, but the tonal variation is still in evidence.

DETAIL 2
The dithering (Epson's alternative to halftones) is subtle enough for the details to stand above it.

HI-FI COLOR VERSION

This picture uses a great deal of blue and red, both colors that are not part of the standard CMYK system. This represents a challenge for most printers.

EPSON PRINTED VERSION (ULTRACHOME K3)

This picture shows that even a limited palette can produce an expressive image. From a printing standpoint, the side lighting means that the resolution needs to be clear enough that the highlights aren't lost in the dithering.

DETAIL
The wood is essentially a gray color so is predominantly composed of the Cool Gray Pantone ink in the 8-color press rendering of this shot.

HI-FI COLOR VERSION

EPSON PRINTED VERSION (ULTRACHOME K3)

DETAIL
The heavy gray bias in the shadows are an opportunity for the Light Black inks to shine, replacing ink-dot grain with the texture detail in the wood.

The color pattern in this photograph is typical of those used to set up a professional grade inkjet printer. Groups of colors like the greens to the right can be especially challenging to reproduce by dithering.

DETAIL 1

The dark skin tones are a mixture of shades that are boosted by the ability to include an orange ink as well as the magenta and yellow that would traditionally do all the work.

DETAIL 2

Getting good quality greens is especially difficult since our eyes are especially sensitive to the green area of the visible spectrum, so a green ink helps.

HI-FI COLOR VERSION

EPSON PRINTED VERSION (ULTRACHOME K3)

DETAIL 1
UltraChrome K3 doesn't have an orange ink, but is able to create subtle, if not quite so vibrant, shades using its Light Magenta and Light Black inks when handling this area of the palette.

DETAIL 2
Just as Light Magenta helps the subtle variations above, the Light Cyan is crucial in mixing the right shades in the UltraChrome K3 ink set.

Perceptually, reds cover a wide range of hues, something that artist Chris Cook takes advantage of as he creates his works, all variations of a dye associated with China. Despite it not being part of the standard color set, it is essential that the subtle differences are seen in your printouts.

DETAIL
The difference between these shades is one of the strongest in the picture, yet it is still not huge.

HI-FI COLOR VERSION

DETAIL
Lighter reds and magentas are still rich thanks to Epson's Light Magenta ink; less yellow creates the pinker shades.

EPSON PRINTED VERSION (ULTRACHOME K3)

This Vietnamese street scene shows a range of subtle colors on the side of a temple and in the man's shirt. All of these colors are reproduced by dithering.

DETAIL

The difference between these shades is one of the strongest in the picture, yet it is still not huge.

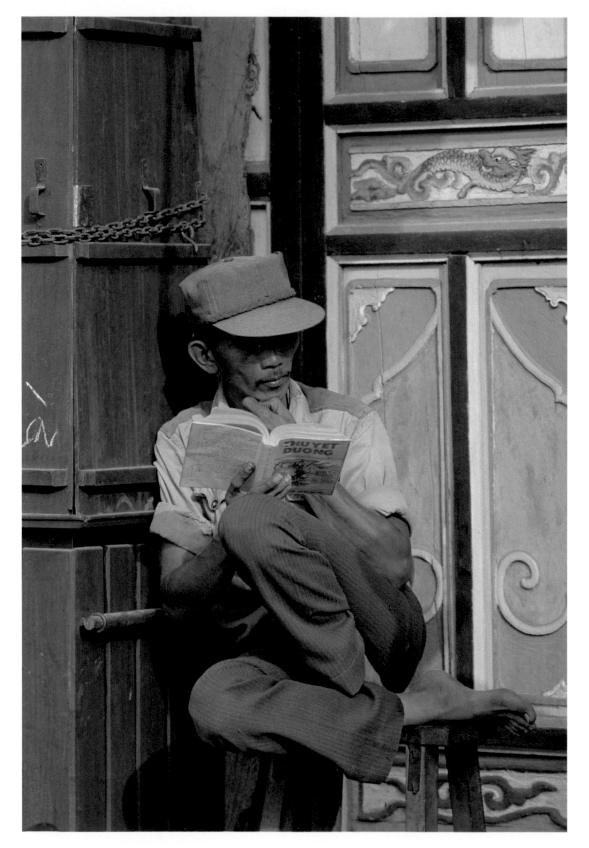

HI-FI COLOR VERSION

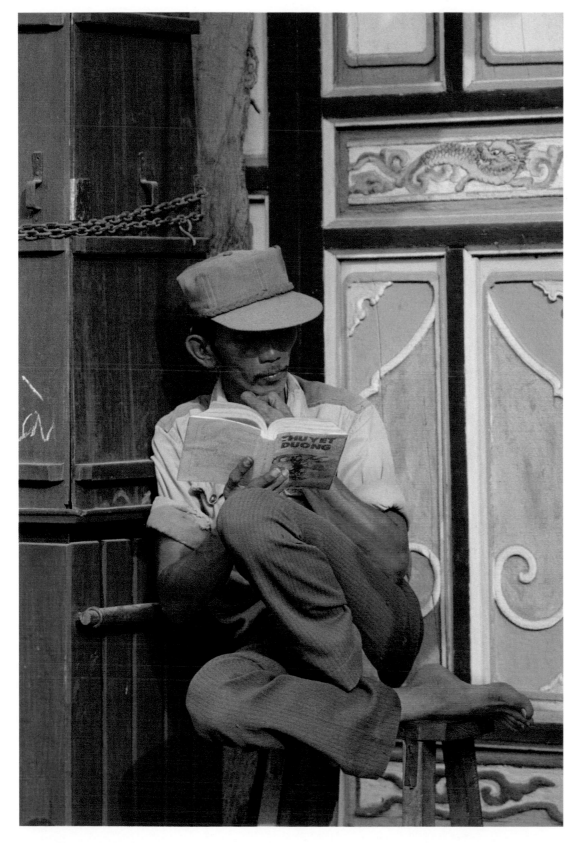

EPSON PRINTED VERSION (ULTRACHOME K3)

DETAIL
Sunlit yellow and yellow-gold seems rich and solid and is mercifully within the gamut of UltraChrome inks.

This picture of palm oil being poured in a Sudanese market has a strong and rich red tone, which is not one found in the standard CMYK inkset. Orange and Red shades are created by mixing the Magenta and Yellow inks, creating heavy ink saturation in this print.

DETAIL

The rich red shade of the sunlit palm oil creates a strong tone that is easily flattened through traditional printing.

DETAIL

The light shades in the background outside the depth of field need to be portrayed as softly through dithering.

HI-FI COLOR VERSION

110

EPSON PRINTED VERSION (ULTRACHOME K3)

DETAIL

The advantage of a Light Magenta is apparent toward the left of this detail, where there would otherwise be more scattered "red" (magenta on yellow) dithering.

DETAIL

The tonal dithering in this light area is soft thanks to the Light Blacks, as well as the hint of Light Magenta and Light Cyan.

DETAIL

The light shades in the background outside the depth of field need to be portrayed as softly through dithering.

HI-FI COLOR VERSION

DETAIL

The light background and darker (but still gray) rock present an opportunity for the two Light Blacks to shine.

EPSON PRINTED VERSION (ULTRACHOME K3)

Color inkjet printers are not just used for color printing, and this comparison makes plain the advantages of additional "Light Black" inks, even in the case of a picture which would merely use yellow and black ink in a traditional 4-color system. As this is the end of the 8-color section, we can also present the 4-color version, which shows the loss in fine detail suffered by the image, especially in the gray-biased areas of the sky around the top of the frame and in the lighter rocks.

Indeed many enthusiasts use an inkset composed entirely of black and lighter blacks for their mono printing, in place of the standard cartridges, such as those from Lyson (www.lyson.com).

DETAIL
The CMYK can create grays from "gray component replacement" (mixing the color inks) and from dithered black.

4-COLOR VERSION

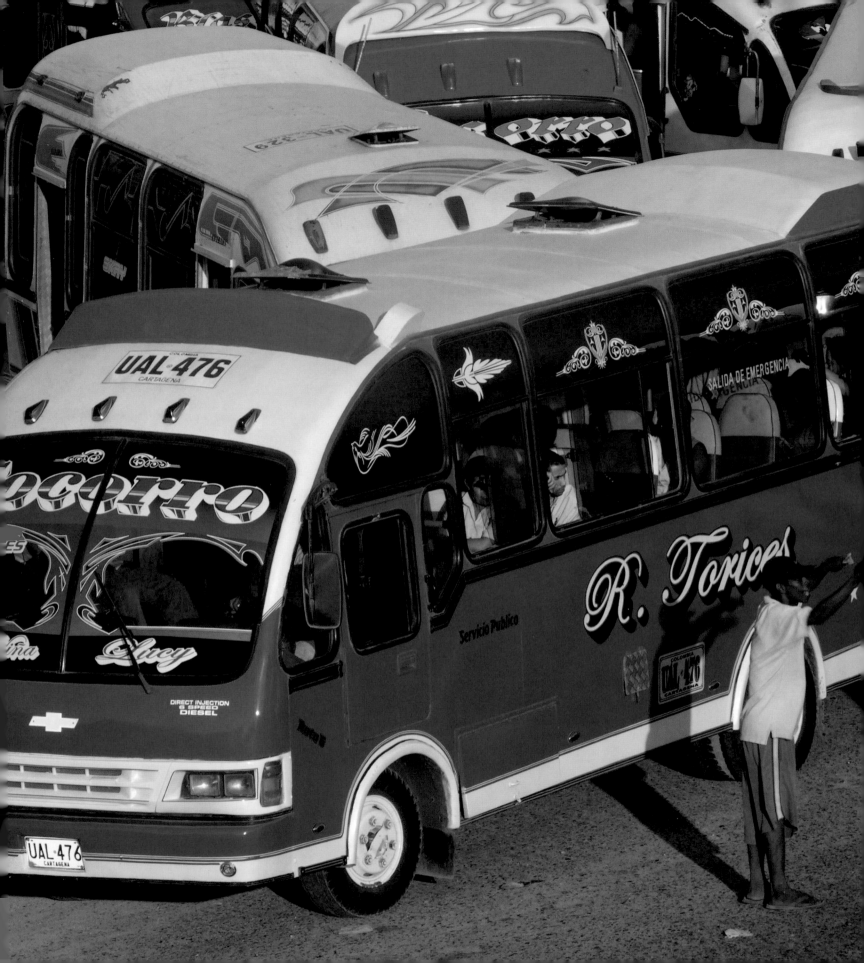

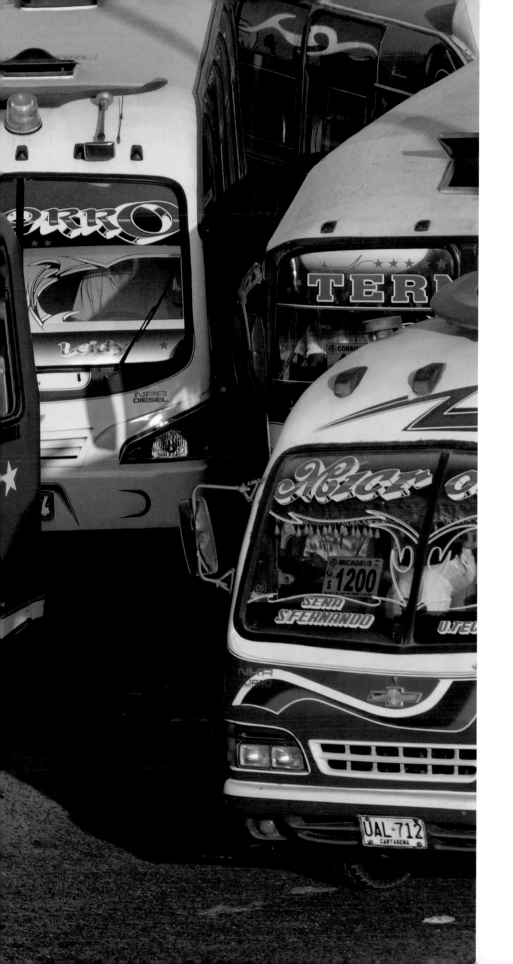

A non-destructive approach

Some pictures seem ready to be printed straight from the camera, with no further work, while others need a little adjustment—brightness and color, for instance, cropping and straightening, even some surreptitious cloning. Whatever work was needed, the image has arrived at the point where the next steps are no longer about perfecting it, but are totally specific to how you choose to output it.

IN THE PAST few years, working "non-destructively" has been a goal of digital photographers. Indeed, the new wave of programs like Lightroom and Aperture are inherently non-destructive. The basic idea is that whatever work you do to a picture, you can always restore its previous condition. This doesn't merely refer to the ability to press Undo during the current work session, but about retaining that sort of flexibility for the longer term. The objective is that you can work on an image and save your adjustments, close the file, exit your software, and still be able to reverse those changes long afterward. That's why it's a great idea to use Photoshop's adjustment layers for all image editing, safeguarding

the original image pixels and leaving you free to fine tune your adjustments later. You don't want to embed your adjustments into the original image.

LEFT: *Output sharpening can also degrade other print-specific adjustments such as a border. Here there's a nasty halo around the border.*

BELOW: *With a little care, however, all sorts of print-specific adjustments such as borders and output sharpening can happily coexist in a single file.*

Note that these images have been scaled, so the pixels are clearly visible.

Principles

The same non-destructive principle applies to preparation for printing—all print-specific adjustments should be totally reversible. Today you may want to print a picture with a 10-pixel black border. You could, if you chose, add the border directly to the image layer, but it makes much more sense to keep the border on its own layer. Next time you print the picture, you can remove the border or set it to 5 pixels, for example. Exactly the same applies to all the other print preparation tasks.

ORIGINAL

EDITED

Another great example is sharpening for print. As we'll see, "output sharpening" is best applied once the image is scaled to its output size. Imagine you had initially made a 10×8 inch print with the right amount of added sharpening applied to the image pixels. That may be OK today, but wouldn't be helpful later when you re-open the file to make a 7×5 print. Downsizing the picture would also downsize the sharpening effect and you'd end up with a soft-looking 7×5 print. You could always add sharpening to the image again, but you would be sharpening existing sharpening and this could produce strange artifacts. Instead, separate all such print-specific adjustments from the image pixels.

It's really important to stress the non-destructive approach because Photoshop now has almost two decades of history. In that time it has accumulated a lot of received wisdom and ways of working, which are—to be frank—obsolete, and yet you are still likely to find in books or online.

For instance, it was common to flatten a picture before printing and saving it. In these days of cheap hard drives, all you achieve is sacrificing your flexibility to fine tune and repurpose your original image.

Sharpening ground rules

- Do all your print-specific adjustment work on image adjustment layers.

- Don't flatten a layered file before printing.

- Save pictures at their full size and with all their adjustment layers.

Output sharpening, edge burning, and borders are print-specific adjustments that can enhance any print.

LAYERS

Normal | Opacity: 100%

Lock: ☒ ✎ ✚ 🔒 | Fill: 100%

👁 ⊘ 🔗 ■ Curves 3 – edge burning

👁 ⊘ 🔗 Curves 2 – darken torso

👁 ⊘ 🔗 Curves 1 – brighten clouds

⊘ Black & White 1

👁 Sharpener Pro 3.0 – Output Charpener *fx* ▲

　👁 Effects

　👁 Stroke

👁 Cloning – spots and bird droppings

👁 *Background* 🔒

🔗 *fx.* 🔲 ⊘. 🗔 🗋 🗑

A fully-worked picture contains adjustments that perfect the image and others that are needed only for printing, and it's important to keep them all separate. Here each adjustment remains on its own layer—there is even a black and white adjustment layer that can be re-activated when a mono version is required.

Sharpening: an introduction

Experts identified three distinct phases of sharpening—capture, creative, and output. The inherent softness of a pixel-based capture means all digital images benefit from a little initial (or capture) sharpening. Creative sharpening comes next and is where you select parts of the image for extra sharpening—around the subject's eyes, for instance. Here we're concerned about the third phase, output or print sharpening.

OUTPUT SHARPENING IS about detecting edge detail within an image, and exaggerating its appearance so the final output looks better. This is done by altering pixels that fall along areas of high contrast (the edges). Pixels on the darker side are darkened and those on the lighter side are lightened. The trick is to add enough of this sharpening to improve the print's appearance, yet not so much that it is visible as a halo or degradation of edge detail.

It's important to remember that sharpening's on-screen appearance can be very misleading. The computer monitor is a lower resolution device than an inkjet printer, and sharpening that looks right on the screen

1 Go to the Layers panel, and activate the top layer. Hold down the Alt/⌥ key, and choose Merge Visible from the menu at the panel's top right.

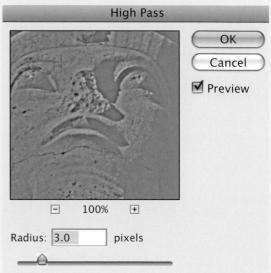

2 From Photoshop's menu, choose *Filter › Other › High Pass*. The new merged layer and the dialog box's 1:1 preview are largely mid-gray, but edge details are picked out in lighter and darker shades. To see what's going on, one little tip is to move the cursor outside the dialog box, and the cursor changes into a little square. Click an important image detail, and the 1:1 preview will show how the filter will affect that part of the merged layer. Assuming your intended print output is 300 dpi, set the Radius to 3.0 and click OK.

may be insufficient when you then print the image. The final print may actually look its best with so much sharpening that its on-screen appearance seems unacceptable. The best way to see and judge this for yourself is by examining a print, but there is a way to anticipate the outcome to some extent.

Research suggests the eye has difficulty distinguishing anything below one hundredth of an inch. This is useful for us, because we can translate the idea directly into numbers to plug into Photoshop. For an image at a 300 pixels per inch output, a radius of 3 pixels is about the limit of what we can apply. At 400ppi, the limit rises to 4 pixels.

Most good sharpening techniques adopt a non-destructive approach, that doesn't sharpen the original image pixels (which in a complex edit might lie on more than one layer anyway). It's better to merge the image pixels into a new pixel layer used purely for sharpening.

While the Unsharp Mask filter can be used for sharpening, it tends to sharpen everything, including areas that don't need it. Instead, a more effective sharpening technique is the High Pass method.

Layer names

It's a good idea to name your merged layer, so you can always see at a glance what sharpening settings were applied.

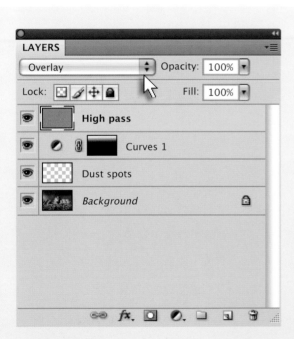

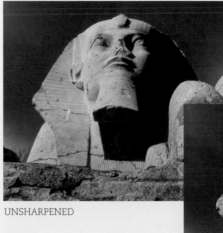

UNSHARPENED

SHARPENED

3 Returning to the Layers panel, change the merged layer's blending mode to Overlay. Photoshop now displays the picture, but with the sharpening applied. What's happening is that overlay, like Soft Light below it, ignores the mid-grays in our merged layer and adds to the composite image only the lighter and darker shades, which we saw around edges in the preview. This increases contrast around the edges.

4 Always review sharpening on the print, not its on-screen appearance. If the effect is too obvious, reduce the layer's opacity percentage and make another print. Alternatively, and also if the print is too soft, delete the merged layer and repeat steps 1–3 with a different Radius. While the sharpened image looked wrong on screen in this example, its printed output is superior to the unsharpened image.

Edge sharpening

Another powerful technique, variously known as edge or smart sharpening, relies on using Photoshop's Find Edges filter to create a mask that identifies edge areas within the image. This allows you to apply a far greater amount of sharpening to the areas where it's needed, while the rest of the picture remains protected. It's a complex technique involving a number of steps, which makes it perfect for recording as an action, but the results can be very good indeed.

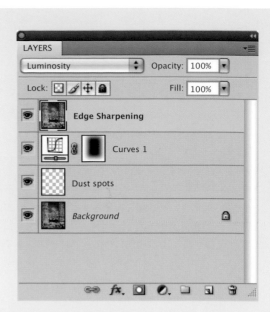

1 Go to the Layers panel, and activate the top layer. Hold down the Alt/⌥ key, and choose Merge Visible from the little menu at the panel's top right. Name this new layer Edge Sharpening, and change its blending mode to Luminosity so that only brightness values will be affected by the sharpening and colors will not change.

2 Activate the Channels panel and examine each channel in turn, looking for the channel with the most contrast. I like to use the keyboard shortcuts, so in Photoshop CS4 that's Ctrl/⌘+3, 4, 5, and then back to RGB with Ctrl/⌘+2 (in earlier versions of Photoshop these shortcuts were Ctrl/⌘+1, 2, 3, and finally Ctrl/⌘+~[tilde]). When you identify the best channel, simply drag it to the Create New Channel icon at the bottom of the panel. This channel will be the mask that identifies the image areas we are going to sharpen, so name it Sharpen Mask.

This approach is not to be confused with Photoshop's Smart Sharpen filter, which attempts to add more sharpening where there is already more contrast in the image.

3 With only the Sharpen Mask channel visible, choose *Filters › Stylize › Find Edges*, which makes the channel look like a line drawing. Edge detail, where sharpening is going to be applied, will be shown in black, and the protected areas of the image are in white. There are also gray areas—these can receive sharpening if we decide they need it, or we can make them white and protect them.

5 While our Sharpen Mask channel now marks out where sharpening will and won't apply, the distinction is much too stark. What we really need is that the transition between the sharpened and smooth areas should be imperceptible, so we now apply some blur with *Filters › Blur › Gaussian Blur*. The amount should be small however—certainly no more than 10 pixels. A value of 3 is often enough.

4 Sharpen Mask should remain the only visible channel. Now choose *Image › Adjust › Levels*, and drag the white triangle to the left and the black triangle to the right—this makes the blacks and the whites much more distinct. This tonal adjustment is critical for what the Sharpen Mask channel is doing—distinguishing the image areas destined for sharpening from those which will be protected. By dragging the gray triangle, we are using our judgement to decide whether intermediate areas will be exposed to sharpening or will be left untouched; dragging left reduces the effect, dragging right increases it.

6 At this point, you may wish to clean up the Sharpen Mask channel a little more. Do so by applying a second Levels adjustment as before, or if you wish you can paint white or black with the Brush tool (B). Remember, black areas will be sharpened, white areas left alone. Now we are ready to move on and apply the sharpening.

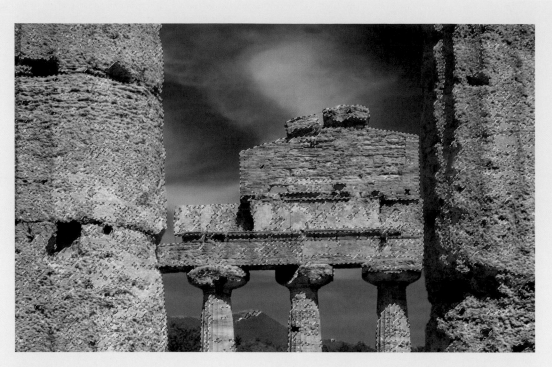

7 Sharpen Mask is still the only visible channel, but we now have to turn it into a selection where the black areas become selected and the white parts aren't. From Photoshop's menu, choose *Select › Load Selection*, and make certain that Channel is set to Sharpen Mask and that Invert is checked. Click OK and you should now see the familiar "marching ants" indicating that we've made a selection.

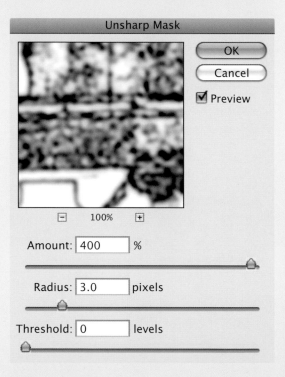

9 The "marching ants" can be very helpful—here they show that the sky is not selected and will not be sharpened, while the temple will be. They can also be distracting, so an optional step is to hide them using the keyboard shortcut Ctrl/⌘+H or menu command *View › Hide Extras*.

8 Our last task in the Channels panel is to display the RGB channel and hide the Sharpen Mask channel by clicking on the visibility toggle icon (the "little eye"). Now activate the Layers panel and make sure the Edge Sharpening layer is selected.

10 Choose *Filter › Sharpen › Unsharp Mask*, and set the amount of sharpening. The advantage of this method is that the sharpening is targeted to where it is needed and other image areas are safeguarded, so you can apply significantly higher levels of sharpening, right up to 300–400%.

As always with sharpening, the real test is not its on-screen appearance. Make a test print and decide if the results are acceptable—a picture that is sharp and without visible image degradation. If you don't like the results, during the current Photoshop session you can use the History panel to go back to step 10 and change the sharpening settings. Alternatively, since the Edge Sharpening layer is separate from the image pixels, you can remove it and create a new version with Alt/⌥+E (Merge Visible). The Sharpen Mask channel is still available.

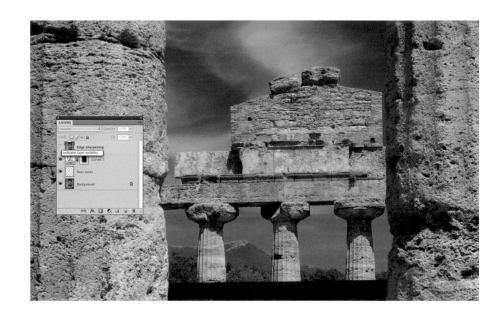

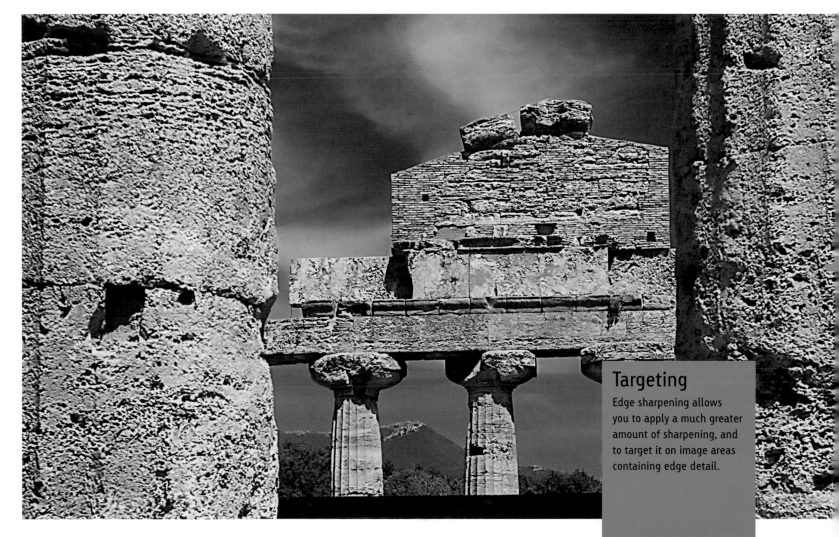

Targeting

Edge sharpening allows you to apply a much greater amount of sharpening, and to target it on image areas containing edge detail.

Sharpening Plug-ins

Another way to get sharper prints is to buy a dedicated sharpening plug-in such as PhotoKit Sharpener or Nik Sharpener Pro. These ready-made solutions offer automated methods of applying various sharpening treatments based on the developer's own research and testing of printer and paper combinations.

SUCH CONVENIENCE COSTS money, of course, and more worryingly it can also encourage an over-reliance on supplied recipes. What makes most sense is to learn the advanced sharpening techniques, such as High Pass or Edge Sharpening, and understand what they are trying to achieve. Both methods give excellent results, and they require little effort if you set them up as Photoshop Actions. Better still, the vendors let you take full advantage of the various plug-ins for 15-30 days by downloading trials and seeing which, if any, works for you. Give them all a try and you'll readily appreciate what this approach offers you.

We can't look at all the sharpening plug-ins here, so let's take a look at one of the better products, Nik Sharpener Pro. This can be installed on Mac or Windows, and appears in Photoshop as an extra panel. It has three main features—capture sharpening, a selective sharpening brush, and the output sharpener, which is relevant here.

1 After finishing your regular editing work on an image, activate the plug-in by clicking the Output button on Sharpener Pro's floating panel.

2 At the top of the dialog box is a Mode drop-down box. You can switch this to a soft proofing view and split the screen so that the left side shows the original image and the right shows the sharpened output. This makes it easier to judge the effect.

3 Now move down the settings on the right-hand side, first choosing Inkjet as the output device. Then consider how you expect the print will be viewed. Generally you can leave this set to Auto, but if the print is only likely to be viewed from a distance, for instance if it's large, then Sharpener Pro can add extra sharpening.

5 The end result is that Sharpener Pro adds the sharpening effect in a non-destructive manner. If you are working with a "traditional" layered image, then the sharpening is added as a merged pixel layer. If you are working with a smart object, then it applied as a smart filter. In either case, make the print and then decide if you like the results. If not, you can always reverse the sharpening and fine tune it.

4 An important setting is the choice of paper. Most paper types will fall under one of the six categories listed in the drop-down box.

Save settings

If you like the sharpened print's appearance, go back into Sharpener Pro and save the sharpening settings as a Preset. If you do a lot of printing, saving the settings will save you a lot of time. And if you don't print very often, saving them will mean you don't have to figure them out each time. You win either way.

Local area contrast

As the eye examines a scene, it is continually adapting to the different levels of brightness it contains. The iris opens up to distinguish detail in the deepest shadows and contracts when you're looking at its brightest highlights. We hardly notice that the real world has such a wide contrast range—more than can be captured by digital cameras or printed on paper. Cameras and printers can't adapt as effortlessly as the human eye.

ONE WAY OF thinking about the printing process is that it is a way of squeezing a wide dynamic range, 8-11 stops, into the 5-7 stops that can appear on a typical print. To fit the image's complete range of tones into that which can be printed means making some uncomfortable compromises—we might try reducing the overall contrast, or alternatively we might make sure the highlights are properly printed and let the shadows look after themselves. Another solution is to apply an S-curve to the image, which essentially compresses the dynamic range in the highlights and in the shadows. More of the print's available dynamic range is devoted to the midtones, which we can see more readily. The trouble is, while the mid-tone contrast may be improved, the increase in image contrast can mean it's at the price of blocked shadows and little highlight detail or definition.

Local area contrast is a neat solution that relies on the eye adapting to print contrast in the same way as when it's examining a real world scene. We tend to appreciate contrast in smaller areas of a print rather than between much larger areas of light and dark tones. So the local area contrast technique is about adjusting contrast between small, neighboring areas of the print, opening up the shadows in those areas and recovering highlight detail.

If you are mainly using Photoshop for printing, you have a couple of options.

1 If you intend to print from a Raw image file, one approach is to push up Adobe Camera Raw's Clarity setting. If you like this idea, then couple it with adopting a modern "Smart Object" workflow—in Adobe Camera Raw hold down Shift and click Open Image Changes to Open Object. This opens your picture in a Photoshop document and encases the Raw image data in a special smart object layer—meaning that the Clarity setting can be changed now or in a later work session: You just double-click the layer, Adobe Camera Raw is restarted, and you can fine tune the Clarity setting.

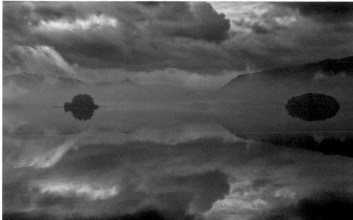

There was a huge contrast range in this early morning scene—much wider than can be reproduced on paper.

Local area contrast gives the final image more "punch" and works well with other print-oriented editing work such as borders, edge burning, and output sharpening.

Unsharp Mask

OK
Cancel
☑ Preview

100%

Amount: 25 %
Radius: 50 pixels
Threshold: 0 levels

2 The other method uses Photoshop's Unsharp Mask filter. As usual, this work should be on a separate layer, so we can reverse or fine tune the effect. Activate the Layers panel, hold down the Alt/⌥ key and choose Merge Visible from the panel's little menu. Then Choose *Filter › Sharpen › Unsharp Mask* and dial in settings such as Amount 25%, Radius 50, Threshold 0.

The Radius essentially defines the size of the small or local areas where we want to increase contrast. Amount is how much you are increasing contrast, while the Threshold is set at zero to avoid artifacts. These exact settings are only a starting point, and it's important to experiment and see the effects on individual prints.

Raw conversion tools

Local area contrast is such a useful tool that it's increasingly being built into Raw converters—in Lightroom it's known as Clarity, and in Aperture it's called Definition. Often you will increase these settings as part of the basic image preparation.

129

Image borders

Unless your print covers the entire sheet of paper, around the picture itself will be the white of the paper. This can be surprisingly disconcerting, especially when the image has lighter areas close to its edge. Instead of a neat and rectangular shape, these bright areas can give the picture a slightly ragged format, and they tend to attract the eye and lead it away from the picture and out into the white surrounding. A thin black border around the picture can solve this, if you forgive the pun, at a stroke.

IT IS, OF course, perfectly possible to make a good-looking print without a border—there is no cast-iron rule. It's much more a matter of personal taste and style, so try it for yourself and print a couple of versions of one of your own images, one with and one without a border. Or take as an example the slightly high key picture here. To my eye, the borderless version seems less "contained" and merely an image with a white area around it, while the version with the border holds the eye and seems more "assertive," more of a deliberate depiction of the scene.

Now we've considered why one would add a border, let's look at how you'd go about doing so. You could of course paint it directly onto a pixel layer, which opens up limitless creative possibilities—some tasteful and necessary, some more ornate. You could soon reach superfluous and distracting.

A simple black border rarely lets you down, and Photoshop's Print dialog makes adding one very quick and easy. On its right-hand side is a drop-down box with two choices— Color Management and Output. Choose Output, and a series of settings appears

Without a border, the eye easily drifts out of the image into the whiteness of the paper, but a thin black border holds attention on the subject.

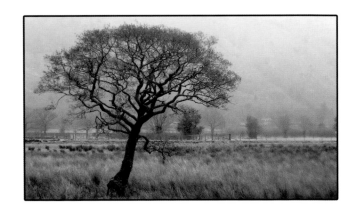

below it, in particular the button labeled Border. Click this, choose a thickness, and you're done.

Adding the border via Print has a number of benefits. It is quick and easy, and keeping the border separate from image pixels means you avoid any risk of the border being accidentally embedded into the image or sharpened. The border has been added non-destructively, so you can close the file and reopen it later to make a fresh print with different border settings. Lastly, Print's border setting remains constant if you resize the picture—no matter what the size of the image, the border will always be the width you set. All these advantages should be enough to make this Print dialog method your default way to add a print border.

Alternatives to the Print dialog method

There are potential disadvantages with adding a border through the Print dialog. One is that its color is limited to black, which may not be a problem in most circumstances, but is unhelpful at those times when you do actually want to choose another color, perhaps picking up an accent color from the picture itself. Another possible limitation is that Print can only add a plain and relatively narrow border—0.15 of an inch (3.5 mm). Again, in most cases that will be sufficient, and there's always a danger of making a border too thick so that it tends to overpower the image. One alternative is to use Layer Styles to add a Stroke to a regular layer.

1 Go to the Layers panel and choose a layer that is completely full of pixels. If you've already added an output sharpening layer, that would be the perfect choice. If not, add a new layer at the top of the layer stack, completely fill it with white, and set its blending mode to Multiply—this makes the white invisible in the final composite image.

Pick Stroke from the Add Layer Style button, and Photoshop displays the Layer Style dialog box. Choose a Size and set the Position drop-down box to Inside.

2 If you want, you can also click the Color patch, which makes Photoshop show its standard color selection dialog box. Choose any available color, or move the cursor over the image and click any color you wish to sample.

The Layer Style method is quite efficient and you can always save your border width and color as a preset. While the border width does remain constant if you resize the picture, there is a downside—resizing the image usually means revising the sharpening for the new output size, and it's easy to forget your border and include it in a new sharpening layer. The telltale signs are a little halo around the picture's edge. It's not hard to avoid this, providing you remember to hide the border before redoing the sharpening.

Patterned borders

Using the Layer Style to add a border or Stroke has a very interesting variation—you can also use it to add a decorative border.

1 Add a Stroke, as before, but in the Layer Style dialog box is a drop-down box called Fill Type. Instead of the default Color, choose Pattern. A thumbnail appears and Photoshop shows the currently-loaded group of Pattern Presets, and to its right is a triangle, that lets you load other built-in groups.

2 You can also add your own patterns to the current group and make them available for use as borders. One idea is to use a detail from an image, so cancel the Layer Styles dialog box, and activate the Marquee tool to select some pixels. Then select the command *Edit › Define Pattern*, and the selected area will be added to the currently-loaded group of Patterns.

3 Go back into the Layer Style's Stroke section, and choose your pattern.

4 Experiment with the scaling options and also with the blending mode settings. This can be a striking and original way to add a border—just take care not to make it too distracting.

5 You can add a quick picture frame effect by choosing Gradient as the Fill Type and setting its Style to Shape Burst.

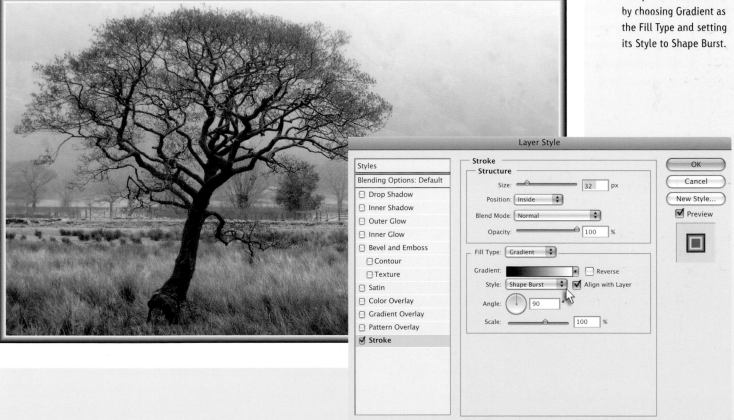

Edge burning

We have already seen that bright image areas can be distracting if they are close to the edge of the frame, and a simple black border can deter the eye from wandering away. Even then, the whiteness of the paper or matte can still glare and make the edge areas appear weak. So skilled darkroom workers have always "burnt in" or darkened the edges and corners of the print, and this "edge burning" technique is no less useful in the era of digital inkjet printing.

WITHOUT BURNING

Edge burning in Lightroom

In Lightroom, use the Gradient tool four times, one for each side of the image, and with the Exposure setting at a negative value. Constrain the tool's direction to 90 degrees by holding Shift as you drag it. (The Gradient tool is not available prior to version 2.)

WITH BURNING

The edge-burning effect should be subtle and believable. If you had never seen the original, you probably wouldn't know it was there.

134

3 With the Curve layer mask active, use the Marquee tool to make a rectangular selection that leaves 5-10% of the mask unselected. Fill this area with black, so that the Curve doesn't affect the center of the picture. Change the layer's blending mode to Luminosity so the edge burning doesn't result in any color shift.

1 In Photoshop, activate the Layers panel, click the new adjustment layer, and choose Curves.

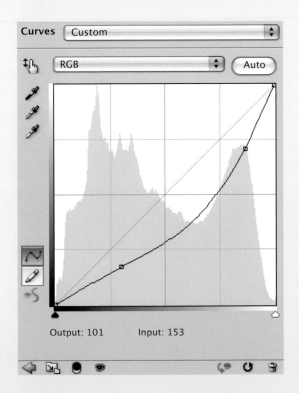

4 Right now, the edge burning is very obvious, so choose *Filter › Blur › Gaussian Blur* and apply a value high enough to hide the edge darkening effect.

Check and review

To review the effect, toggle the Curves adjustment layer's visibility. The effect is non-destructive—you can change the Curve, redraw the rectangle, and blur it again.

2 Drag the curve downward, not too radically because the shadows are already dark enough and you don't want to block them. Instead we need to subdue the midtones and the highlights around the picture's edge.

Creative printing in Lightroom: Triptychs

We've already seen how Lightroom is a streamlined tool for managing your pictures from camera to printer. It certainly makes basic printing easier and makes light work of utilitarian tasks like adding plain borders, output sharpening, or adding copyright overlays to proofs. So some Lightroom users will do more detailed image manipulation over in Photoshop but will then return to Lightroom for printing the pictures. It's an approach that saves even more time when you're running off batches of prints. Lightroom is designed to be efficient.

WHAT IS A lot less obvious is that Lightroom's Print workspace can also be used creatively, so let's take a look at a couple of ideas. One is printing a diptych or triptych, but printing two or three images on the same sheet is rather mundane—here we're going to make Lightroom print alternative versions of the same original picture. Second, we're going to add a fancy border, a job which is really Photoshop's territory but which is also possible in Lightroom. Each technique can work on its own, but in this example we're going to use the two techniques together.

In Lightroom's Print workspace, the Overlay panel adds the Identity Plate as an overlay on the print. This was originally envisaged to be a way to include a photographic studio's logo or other corporate branding, but it can also be adapted to let you add a copyright watermark to protect your work.

1 "Virtual Copies," or alternative treatments of the same original, are the key to making our diptych or triptych. In Lightroom's Library, switch to Grid view (G) and right click your chosen image. Then, from the

Layouts

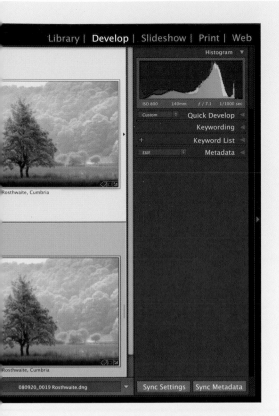

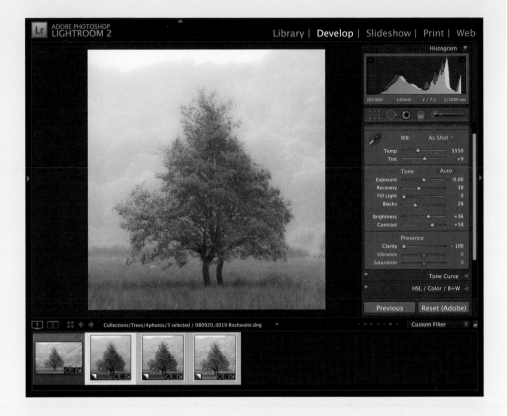

context menu, choose Create Virtual Copy and Lightroom will create another thumbnail of the picture with a little torn corner. Repeat this for the number of alternative versions you want,

2 Take each virtual copy over to the Develop workspace and adjust it as you want. Here I ended up with a straight black and white version, another split-toned with sepia and blue, and a third sepia-toned one with a negative Clarity value to produce a soft focus effect.

The Layout panel's rows, columns, and spacing settings can produce all sorts of results when used in combination with Zoom from the Image Settings panel. So experiment!

3 When the virtual copies look ready, select them all and go to the Print workspace. In the Right Panel (F8) make sure that you have Contact Sheet/Grid selected in the Layout Engine panel. As its name implies, this is the easiest way to make a single proof sheet containing lots of thumbnails, but it's also great for other more interesting multiple image layouts.

Layout ▼

Ruler Units:	Inches ⇕
Margins	
Left	0.25 in
Right	0.57 in
Top	0.25 in
Bottom	0.25 in
Page Grid	
Rows	1
Columns	3
Cell Spacing	
Vertical	0.00 in
Horizontal	0.28 in
CellSize	
Height	4.22 in
Width	3.44 in
☐ Keep Square	

Layout Engine ▼
Contact Sheet/Grid
Picture Package

4 In the next panel down, Layout, set the number of rows or columns to match the number of images that you wish to print. Adjust the spacing and sizing of each cell until the preview looks right.

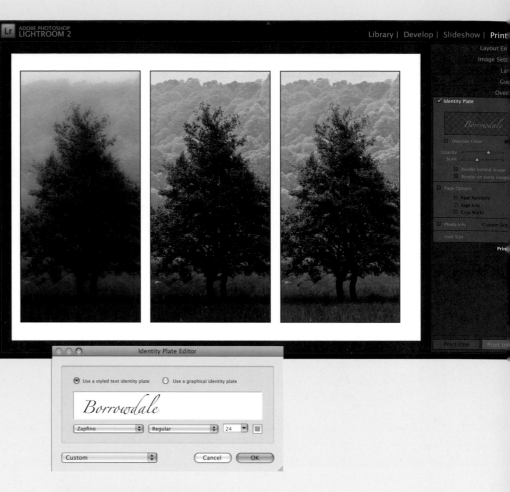

5 Back in Lightroom's Identity Plate Editor, locate the frame image and click OK. Choose Render on Every Image (in the Overlay panel), and scale it to fit, to display each version in an ornate picture frame.

7 Add some text, choose a font and color, and click OK. You can also position and scale the results.

6 In the Overlay panel, tick the Identity Plate's check box and choose Edit from the little menu on the preview.

8 Edit also allows you to specify that the Identity Plate should come from an external image file, so click the little edit menu in the Overlay panel and locate the image you wish to use.

TIFF Options

Image Compression
- ● NONE
- ○ LZW
- ○ ZIP
- ○ JPEG

Quality: [] Maximum ▲▼

small file large file

Pixel Order
- ● Interleaved (RGBRGB)
- ○ Per Channel (RRGGBB)

Byte Order
- ○ IBM PC
- ● Macintosh

☐ Save Image Pyramid
☑ Save Transparency

Layer Compression
- ● RLE (faster saves, bigger files)
- ○ ZIP (slower saves, smaller files)
- ○ Discard Layers and Save a Copy

[OK] [Cancel]

LAYERS
Normal Opacity: 100%
Lock: ☒ ✎ ✛ 🔒 Fill: 100%
👁 Layer 0

9 It's best to say a few words about type of external image that works best. While Lightroom can overlay many types of file over a print, for our fancy frame treatment it's important that our Lightroom pictures appear through the frame. So the external image should be saved as a file type that supports transparency, and any transparency options should be ticked when saving the file. Use TIFF, PSD, or PNG.

10 Lightroom can overlay an image of any size you wish, but—as with real life framing—it's important that the frame's proportions to match those of the pictures we're framing (proportions since Lightroom can scale the overlay image). So here I created a 210 × 270 pixel frame in Photoshop, corresponding to the 2100 × 2700 crop (shown in the EXIF view in the Metadata panel in Lightroom's Library).

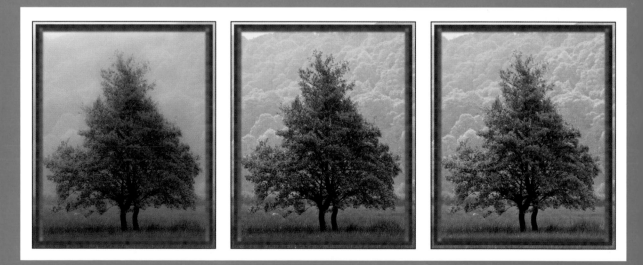

Fancy picture frames aren't to everyone's taste but give some idea of the creative possibilities offered by Lightroom's efficient Print module.

Flipping the image

Another last minute printing trick is to flip the image horizontally. In the darkroom it often happened by accident—holding a strip of film up to the light, you might not even notice it was reversed and would promptly put it in the carrier that way.

EVEN WHEN it was a deliberate decision, flipping the image horizontally was just one innocent step towards making a great print. It's equally easy to flip a digital image, yet for some reason seems to be done very rarely. Perhaps it's the fear of being caught out, and of such a minor subterfuge undermining all faith in the image. Whatever the reason, one should never be reluctant to flip an image.

It's trivially easy to do. In Photoshop, choose *Image > Rotate Canvas > Flip Horizontally*. Not just the image pixels, but the entire document, including all pixel layers, adjustment layers, and masks are reversed. The equivalent in Lightroom is *Photo > Flip Horizontal*. Decide if you like the result, and Undo or Redo it until you've made up your mind—it's that simple.

One idea is to make a copy of the picture and compare the flipped and original appearances. In Photoshop you need to choose *Image > Duplicate*, flip one of the documents, and then use *Window > Arrange > Tile* to position the versions side by side. In Lightroom create a virtual copy (Ctrl/⌘+C) and then go into Compare mode (C).

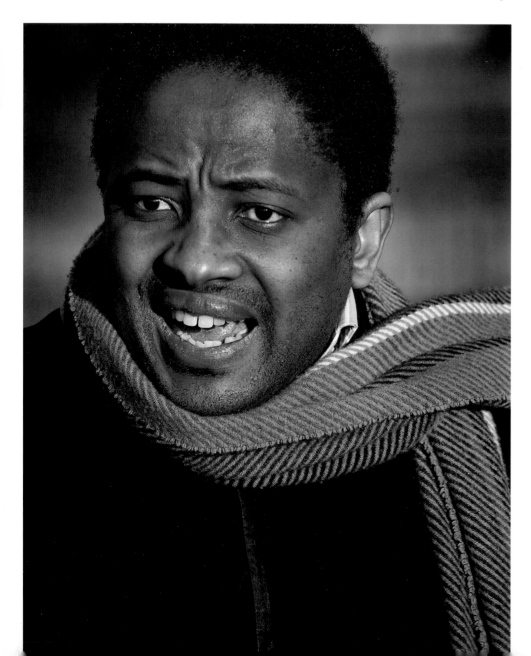

Reading the image from left to right, one tends to look at the man's eyes.

In Lightroom's Compare mode, place the original next to a flipped virtual copy. Here the original seems better— perhaps because the light comes in from the bottom left and leads the eye into the scene.

Of course, not every picture can be reversed. Backward lettering would be a dead giveaway, while a landscape might be recognized, but portraits, wildlife work, and abstracts can often benefit. It also pays to be cautious— you'd be surprised how people will notice the smallest inconsistencies.

Much depends on the individual composition, but it's also important to consider the factors that influence how we tend to examine a picture. One is that we read text from left to right and there's a corresponding tendency to do the same with pictures. Another is the importance of the face and particularly the eyes, and in the main example on these pages, these considerations are both in play. Looking at the original version, reading from left to right means that we are immediately drawn to the man's eyes—and stop. The flipped version strikes me as more successful and more dramatic—we are led by the scarf across the image and then to the eyes. As here, it's often a marginal decision and highly subjective, but it's so easy to flip an image and see if it's improved. The hardest thing is to remember to try it before making the print.

Flipping this image horizontally seems to give it more drama, but it's a very subjective judgement.

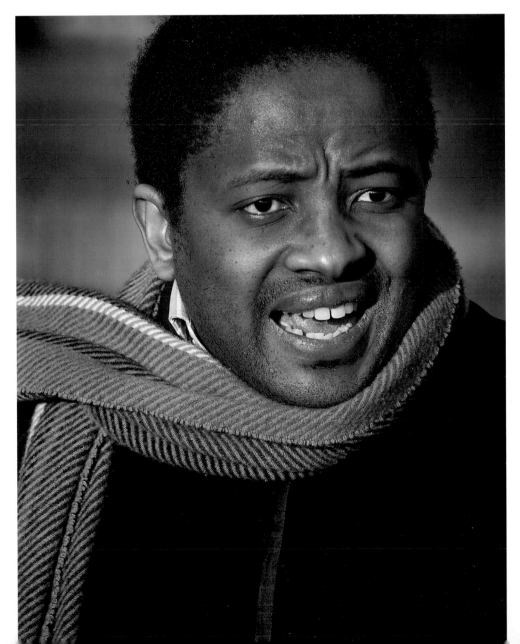

Black and white

Black and white is often a reason why people first fall in love with photography, and there are plenty of digital photographers who print all their pictures in mono. Even then, shooting in Raw format on a digital camera offers them the great advantage that the choice of black and white or color is no longer fixed forever at the point of capture or when you load a roll of film. It's a decision that you can happily put off until you power up the printer.

PHOTOSHOP RARELY OFFERS one way to do something, and you can easily get into double figures counting up methods for turning color into black and white. Twin Hue/Saturation layers, Lab mode, Channel Mixer, RGB layers, and so on. Even truly vintage techniques like Image Calculations regularly find themselves being disinterred and given a fresh look in books or online—despite trailing far behind more recent methods' efficiency and flexibility. To cut short a very long story, since Photoshop CS3 it has been perverse to use any other method than the black and white adjustment layer.

Some pictures work equally well as black and white or color versions.

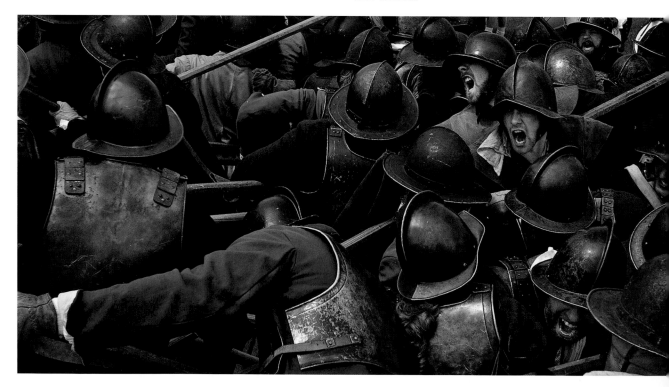

1 Start off with your color image with all its layers—both those which correct the basic image and the print-specific work like output sharpening and borders. From the Layers panel, add a new Black and White adjustment layer at the top of the layer stack.

2 The Black and White adjustment layer lets you control the grayscale rendition of each color. Dragging a slider to the right makes that color render lighter, to the left makes it darker in black and white. There are also presets that simulate the effect of colored lens filters, but best of all is the little targeted adjustment tool that becomes available once you click the small hand. As you drag this over the image, Photoshop senses the color of the pixels and moves the corresponding sliders. Drag to the left and those colors are made darker in black and white, drag to the right to brighten their rendition. The beauty of this is that all the while your eyes are firmly fixed on the picture and on making it look its best.

3 The effect of different settings can be very dramatic. On the left is the result of using the black and white adjustment layer's red filter preset. If you're familiar with black and white film, you would know that a red lens filter would allow the passage of light from the red part of the spectrum. So something that is red or yellow would appear lighter. While this looked good on most of the image, the original also contained blues and a red filter blocks light from that part of the spectrum. So in black and white terms, it makes blues appear darker.

That's what happened here. The red filter result shows the pole or pike below the man's arm in light tones—it was a yellow-brown—and it made his arm darker. This drew attention away from the strong diagonal of his arm and the pike which runs up toward the top left.

Compare the results of using the blue filter preset (on the left). The arm is much lighter and more obvious, while you no longer notice the other pike in that part of the image.

It's these considerations that lie at the heart of the art of black and white. Using Photoshop's targeted adjustment tool is the best way of keeping your eye on the picture itself and your attention on how pleasingly the grayscale tones are distributed around the picture.

143

4 It's not at all unusual that different parts of the picture will need different conversion recipes. The skill comes in recognizing the issue, because working with adjustment layers means the solution is very easy—add more than one black and white adjustment layer. Here one has the blue filter preset and its mask is painted with the Brush tool so the adjustment layer only affects the right hand side of the picture. Above that, a second adjustment layer uses the red filter preset to convert the rest of the image. As you grow more experienced with black and white work, this sort of approach is very typical because it really makes the best use of all the color information in the original picture.

5 When you convert a picture to black and white, carefully review your existing print-specific adjustments. Thin black borders will be unaffected, obviously, as will your output sharpening layer if you set it to Luminosity blending mode, but the frame's edges merit careful examination. As we've just seen, the black and white conversion recipe can very easily change a dark-looking color into a very light grayscale tone, and bright areas close to a black and white picture's edge are infinitely more distracting than in the color original. So make a quick search for anything such as at the bottom left of this image—someone's white cuff.

6 Once you are considering more "local" problems, the solution tends not to be another black and white adjustment layer. One alternative is a tighter crop, but in this case that would cut off some of the armour slightly to the right. Another idea is to clone some detail from elsewhere, but in this case my choice was to "burn in" or darken the collar and some other bright areas. Add another Curves layer and drag down the right hand side of the Curve, so any whites would be rendered as a gray. Then fill the adjustment layer's mask with black (essentially this is the same method as Edge Burning) and use the Brush tool to paint white where I wanted the Curve to apply.

LAYERS

Luminosity | Opacity: 100%

Lock: | Fill: 100%

- Black & White
- Black & White
- **Curves – collar**
- Curves – faces
- Curves – edge burning
- Sharpener Pro 3.0 *fx*
 - Effects
 - Stroke
- *Background*

7 Once you are happy with the picture, make your print and save the file. If you want to make a color version one day, just open the file, activate the Layers panel, and switch off the visibility of the black and white adjustment layers. One file contains both versions.

Dealing with bright edges

- Crop more tightly
- Clone details from elsewhere in the image
- Darken the area with a selection and the Curves tool
- Separate B&W adjustment layers

Sandwiching

By combining the scanned texture of a traditional photographic paper with a digital file, a convincingly historical print can be created in your image editor.

1 Use a flatbed scanner to scan in any paper or other material which catches your eye. Even if you have no immediate use for it, you can add it to a collection of found textures such as here in Bridge where I've gathered some tissue paper, a torn brown envelope, and some ornate writing paper. The paper's color is not very important—while it may prove useful, it's the texture that's of more value.

2 When you are ready to create a sandwich, open the image and the texture file in Photoshop and use *Window › Arrange › Tile* to position them side by side. Drag the material layer from its Layers panel and drop it into the picture. Make sure it's the top layer in the stack.

3 The scanned material is unlikely to be the same size as the picture, so resize it using *Edit › Transform* or Ctrl/⌘+T. Drag the "handles" to resize the image, and maybe try the Warp distortion option. This makes it easier to re-use the material on other pictures without people recognizing it. When you're done, press Enter to commit the changes.

Advancing over the battlefield, wouldn't it be great to make these 21st century re-enactors look like they're in a 19th century photograph?

Smart objects

Consider making your textured material into a smart object—click the layer and choose *Layer › Smart Object › Convert to Smart Object*. This means the texture can be adjusted or stretched, or filtered as much as you want—and you can always return to your starting point and try another effect.

4 The scanned material now hides the image, so the next step is to make it transparent. One helpful feature is at the top of the Layers panel where you can change the Opacity percentage.

6 Experimentation and ingenuity is the key to this technique. Try different combinations of Blending Mode and the Opacity percentage. Here the Soft Light mode gave the picture the distressed appearance I had imagined, but it was too stark, so I countered the contrast increase by reducing the layer's Opacity.

5 Just to the left of Opacity is the layer's Blending Mode. This drop-down box contains options to control how the current layer's pixels combine with the image's other layers. First try Darken and Multiply, which mean only the material's darker pixels affect the final composite image. Lighten and Screen which have the opposite effect. Equally useful is the group beginning with Overlay where you can combine the scanned material in ways that increase contrast.

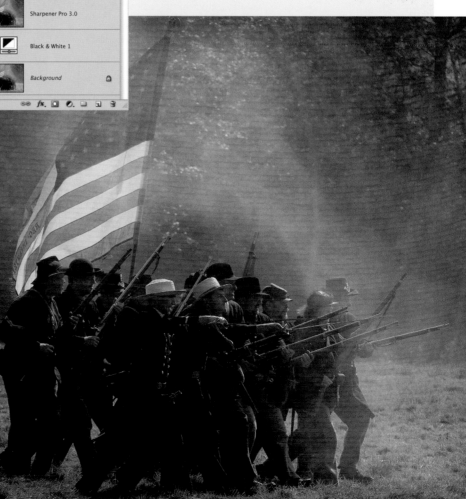

Film rebate

There was a time when it was fashionable to print images full frame and including a bit of the negative as a border. The rougher the better, too, and even the film stock and sprocket holes were printed. It was striking at first for its originality, and also as a demonstration of the photographer's ability to get it right in the camera. Though one still encounters the style with new prints, now it seems more a statement of the photographer's continued use of film and the darkroom, and it's less of the cliché that it became. There's no real equivalent in digital imaging, but any modern capture can be given the look—and easily too.

Film resource

You are going to need to get hold of some film. If you started your photography with a digital camera and don't have access to any negatives or transparencies, do a quick search on the web and you will find a few people have made available JPEG or Photoshop template files made from original film.

This peaceful scene works well with a plain border and it has a timeless quality.

1 If you have some film, it's not too hard to make your own frame with a flatbed scanner. Mine has a transparency adapter so I inserted a strip of black and white film and scanned it directly into Photoshop. I chose a high resolution, 1600ppi, so that the scanned file would be similar in size to digital captures—in this case a 2¼ inch (6 cm) square negative would become a 3600 pixel scan.

2 As well as straightening and cropping the scan, the biggest task is to remove the negative's existing image. Double click the background layer to make it into a standard layer, and then delete the picture using Photoshop's selection and masking tools. Take time, especially when you have an irregularly-shaped negative such as mine. You'll be left with a transparent central area and can use this template again and again with different photographs.

4 You will probably need to resize the film layer, so use *Edit › Transform* or Ctrl/⌘+T and stretch it to fit the image. Hold down the Shift key so the frame's proportions are maintained, and also the Alt/⌥ key so that you can resize in all directions at once.

A film edge gives this digital capture a distinctive appearance.

3 Open both the film template and your main image and position them both on screen Activate the film template and go to its Layers panel, then drag the layer and drop it into the main picture. Here you can see the original color image as the background layer, a black and white adjustment layer, and my film template now at the top of the layer stack.

Split toning

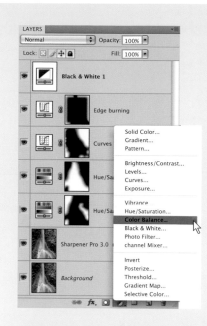

Your Epson inkjet printer can produce great black and white prints, but the art form is in no way limited to pure shades of gray. Photographers have always added and appreciated the value of subtle colored tones, so a faint hint of blue gives the monochrome image a coldness, while sepia is a cliché of a nostalgic or romantic look. Split toning takes this idea further and applies one color to the image's highlights and a second tone to its shadows. Your Epson inkjet printer is perfectly capable of reproducing these colors.

PHOTOSHOP HAS TWO decades' worth of accumulated techniques, and one old toning method that's still touted is duotone. Sadly it's an old fashioned "destructive" method, forcing you to switch the image to 8 bit mode and to Grayscale, throwing away any color values and some adjustment layers. After you save and close the file, these changes are permanently set into the pixels, so you will have to keep multiple copies of your file if you expect to print color or other versions in the future. For the inkjet printer, duotone has had its day—more recent techniques are more flexible.

1 In the Layers panel, add a new adjustment layer. Choose either Color Balance or, if you're feeling more adventurous and want total flexibility, Curves.

2 If you choose Color Balance, click the Shadows radio button and then drag the color sliders to add a tone to the shadows. Don't drag too far—a subtle hint works best. Then switch to Highlights and add another tone. That's it.

Rules are made to be broken—while there's an edge burning layer, the bright areas close to the edges were left untouched.

Lightroom split toning

Lightroom has a built-in toning feature. In Develop's right panel, go to Split Toning and drag the Highlights Saturation slider to the right, so that the color starts to show, and drag the corresponding Hue slider. Then repeat with the Shadows sliders.

3 If you decide to choose Curves, hold down the Alt/⌥ key when you click the Create New Fill or Adjustment layer icon, and Photoshop will display the new adjustment layer dialog box. Set the layer's blending mode to Color. This is important because it limits the Curve's effect to the color, and leaves image brightness unaffected. If you forget to hold down Alt/⌥, you can choose Color blending mode later in the Layers panel.

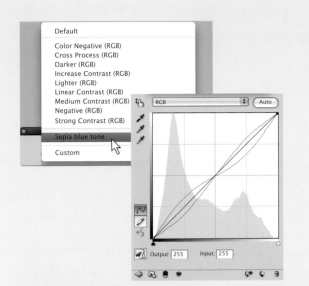

6 You should adjust more than one channel for the most subtle effect. Here I dragged blue in the opposite direction to the red, so there is more blue in the shadows and less in the highlight areas. The result is a split tone with sepia highlight and blue shadows. When you like an effect, save it as a preset so it's easy to apply to other pictures.

Using Color Balance or Curves adjustment layers allows you to create an infinite variety of split-toned effects.

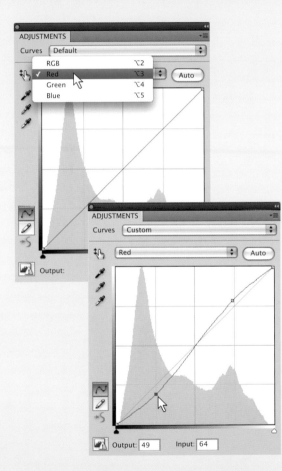

4 The Curves-based technique is all about adjusting the RGB channels separately. From the drop-down box, choose one of the colors.

5 Click a point on the curve and drag it upward to add that color, or downward to remove it from the composite image. Here there is more red in the highlights—the upper right, and less red in the shadows and therefore a green-blue tone in those areas.

PRESENTATION AND DISPLAY

Trimming

Some inkjet printer users never trim a print, simply using sheet sizes to match the frame or storing prints in boxes, or piles. But for most people, printing a couple of pictures on a single sheet makes perfect sense: You don't need to keep smaller sheet sizes and make the best use of expensive paper—it's a routine task to trim and separate them later.

BUT TO DO it well you'll need some simple equipment and to take your time cutting one single sheet at a time—in a single slash of the blade you can ruin a print, or even cut yourself if you don't take care. To get it right, it's important to be able to measure accurately, to use the right tools, and be sure every corner is a perfect right angle. At all times it's wise to remember and follow that well-worn adage: "Measure twice, cut once."

Let the print dry
Trimming necessarily involves handling the print, so it is always a point of increased risk of some sort of damage, whether it's a fingerprint, a crease, or worse. So, at the risk of stating the obvious, let inkjet prints dry thoroughly before you trim them. They may appear dry within minutes, but drying is usually only complete a few hours later. Where's the rush?

Measuring
Accurate measuring is essential, so use a high quality, clean, and well-marked transparent acrylic ruler, preferably with the scale engraved on the bottom to avoid errors should

Cutting mats "heal" themselves for longevity, and help you to cut in a straight line.

Programs like Photoshop, Bridge, and Lightroom have "picture package" features to print different images on a single sheet of paper, or the same image in a variety of sizes.

you view it at an angle. One with additional grid lines will enable you to see the artwork underneath so you can more readily check the alignment and avoid making measuring mistakes.

Make sure your ruler is at least as long as the largest length of work you do, and look after it by protecting the edges and keeping it absolutely clean. Most of all, remember this ruler should never be used when cutting. Even if you don't wobble and cut yourself you will certainly damage the edge of the ruler and render it useless for drawing straight lines afterwards.

When you measure, get used to making very light pencil marks with a well-sharpened soft pencil. You don't need to draw a complete line, just mark the corners. You will need to remove any small pencil marks with a good quality eraser at a later stage.

Cutting mats

Ideally you should always cut prints on a special cutting mat. These are widely available and relatively inexpensive, and serve a number of purposes. As well as helping you hold the print so it won't slip, a mat protects your table from accidental damage and makes blades last longer. What's more, because the mat's specially-made surface "heals" itself after each cut, it also guards against the risk of the knife being channelled into a cut made during a previous session, which is why a proper cutting mat really helps you to cut in a straight line, time after time.

A steel or steel-edged ruler is necessary for cutting; the blade will be inclined to cut into plastic and wooden rulers, ruining both print and rule.

Trimmers

The most common types of paper trimmers are guillotine and rotary paper trimmers, and a lot of specialist manufacturers produce equipment designed to accompany inkjet printers. Look for one that is big enough to take the length and thickness of paper or board you will be using. Both type of device usually offer more consistent results than a hand-held blade.

Rotary paper trimmers use a round cutting blade, which slides along a rail. These are much more common nowadays, not only because of safety concerns, but also for their ease of use and accuracy with paper and light card. Good ones have a clamping strip to secure the work, and provide a clear view of the cut. The rotary trimmer blades are able to cut in either direction, which helps with speed, and are often self-sharpening, so low maintenance.

Cutting by hand

Hand cutting is a skill well worth learning. Mounting and presenting your work will always involve some cutting by hand so equip yourself to do it well—and safely.

Use a good craft knife and a fresh blade. Look for a solid, heavy-duty design for general work and a finer, more delicate knife for thinner materials that will need less pressure. Snap-off knives give you a simple way to ensure you use fresh blade for each new piece. The more delicate scalpel or craft blades have their uses, but be warned that they can twist and flex, and even snap under excessive pressure.

Always use a metal ruler or cutting edge, if possible one with a finger guard. Look for one whose edge is upright, not bevelled, and if it has inch and centimeter markings it might have more grip. Many also have a rubber anti-slip underside, but be careful that neither this nor the markings have any texture that might mark the print.

Craft-knifes can be convenient, but make sure they are specified for the type of material you wish to cut.

A heavy-duty trimming knife is a good investment.

A guillotine cutting tool. These are fantastically quick and easy to use, but not ideal in family environment because of the exposed blade.

Guillotines contain a large blade that can cut up to about ten sheets of paper and can also be used to cut cardboard, textiles, and other materials. They are available in a range of sizes and generally have a guide, a ruler, and a grid pattern to help ensure that your cuts are straight.

Picture framers often use a special wall-mounted board cutter to cut sheet materials (mount board, hardboard, foamboard, and glass). Clearly these machines are not designed for home use, but do guarantee speedy, accurate, and stress-free cutting of the much larger sizes of board. Maybe you could find a framer who can supply materials cut to the size you need.

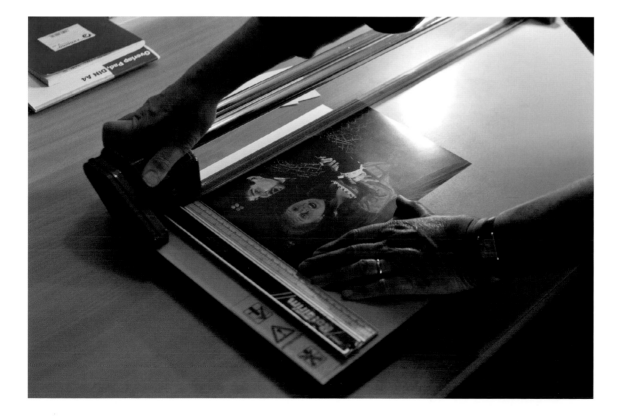

A rotary paper trimmer is a safe and reliable way to cut paper; the blades are kept well away from fingers.

Mount cutting

The bevelled window mount or matt is as close as we get to having a standard way to display inkjet prints in glass frames, and a huge choice of archival quality mountboard is available from specialist suppliers. While you will rarely go wrong with white, you still have to choose between warm and cool shades, and there are times when a color may really suit the picture. Virtually any style or design you can imagine can be created.

BUT LET'S NOT forget that this piece of card is there for a reason—combining elegant presentation with protection. Its function is to protect the artwork and stop the print coming into direct contact with the glass. The print or object being framed needs air between it and the glass—otherwise it may stick to it, leading to problems with mould growth, discoloration, and permanent damage to the print.

Of course, you don't need to make the mounts yourself. You might get one cut for you after making the print, or alternatively you could buy a batch and then make your prints to fit. While the latter idea may save money, wouldn't it be a shame to crop images merely because it suited the mount? That approach may work well if you consistently make prints to certain dimensions, but to be truly flexible you will have to do it yourself.

Cutting a window mount is easy enough, but you'll find that cutting the window perfectly takes a little practice. Inexpensive hand-held cutters are available from many craft stores and these will get you started. Each time you use one, make sure the blade is sharp, that the cutter is clean, and you are working on a surface with decent grip and which is suitable—a cutting mat is ideal. Also, make sure your hands are clean and dry—quite apart from the fact that you don't want to slip and cut yourself, you will also need a new sheet of mount board for each bad cut you make.

Window mounting

8 inches

90°

10 inches

1 With the mountboard face-down on the cutting mat, use a sharp but soft pencil—grade B—to mark up the exact required frame dimensions (eg 8 × 10 inch or 250 × 300mm). Use both a see-through plastic ruler and a set square to ensure all the corners are accurate 90-degree angles. Also, extend each line at the corners so you'll always be able to see where the lines are, even if your hands or the cutter are in the way.

2 Each cutter system has a slightly different way of setting the stops to mark the start and end of cut positions. Refer to the instructions for your mount cutter and set the stops accordingly. Then work systematically around each side of the mount. If your hands get sticky, stop and dry both them and the cutter.

3 Once you're done, carefully examine each corner. Do not attempt to pull out the center if it is still attached to the mount. Instead just slide a craft blade along the angle of the cut and gently finish the corner.

4 Look at the window and check it carefully. Overcuts are to be avoided, but small ones can sometimes be "burnished" away—there's no need to hurry. It is perfectly possible to have multiple layers of mounts, known as double matting or triple matting. This allows the framing of deep, or floating objects, and can be very decorative. With a print, perhaps it looks a little fussy and overbearing, but that's your call.

Above: Professional mount cutting systems like this from Longridge (www.longridge.co.uk) are sturdy, accurate, and safe.

Above right: A mount cutter is a simple hand-held tool.

Equipment

With some practice, quite sophisticated window mounts can be achieved with very basic (and modestly-priced) hand-held cutters. Don't worry if the first few results aren't quite perfect, because you will find that the more you cut, the better they become. Everyone has to start somewhere.

Once you have created some simple window mounts you might feel the need to be a little more creative or efficient. Any straight-cut mount-cutting machine will improve your speed and accuracy, and they will also allow you to create more adventurous shapes and multiple aperture designs. They are well worth considering if you cut mounts on a regular basis and are an essential part of the armory of tools found at any professional framing studio.

There are several good manufacturers of mount cutters, and their ranges include models of varying size and complexity. In general, they all employ a sliding cutting head, similar to a rotary trimmer, and more sophisticated machines can cut at different angles and have production stops. These allow the user to create batches of window mounts—very helpful for consistency or when you're working on an exhibition or batch of prints.

Look for a model that can handle the largest prints that you expect to make. Some come with a gauge and built-in ruler, stops, and guides so you can make the cuts accurately and hold the mount securely while you're working. It's also a good idea to try one out at a trade show, particularly if you are left-handed.

Visual choices

Mount cutting is an art that can truly show off your flair and creativity. Choosing the most appropriate designs and selecting colors and combinations takes time, and need not be rushed. After all, the result could well be in your home, on display for years.

You may not be able to choose a mount board simply by examining a color card. Far better to see the board itself by visiting your

framing or arts supplies shop, or by obtaining corner samples or off-cut pieces that can be compared with the print. This allows you to test double-mount combinations and assess the appearance of different surfaces, and also perhaps see it in the lighting conditions where the framed picture will be displayed.

As well as trying combinations of colors and surfaces, the space and layout of the mount needs careful consideration. Pictures need space to "breathe" in the frame. Equally, if you have too much space, the picture may become "lost." But it's very much a matter of personal judgement—a small image can look striking in the center of a large frame.

With straight mount-cutting machines it is relatively easy to produce an opening in a mount with an even border. But pictures often look more comfortable with the bottom border just a little larger than the other three. Many framers routinely add to the "weight" of the bottom border by up to an extra 10%. This is a matter of personal choice and you should learn to trust your eye in these decisions.

Mount board is available in every imaginable color

Mount matching

Here I've tried to match the mount to a color in the image, but the surrounding appears to overwhelm the subject.

A strongly-colored window mount can be cut so it exposes the print's white border. It is also common practice to lift the image so it's slightly closer to the top than the bottom.

Traditional framing

The style and decoration of frames has always reflected prevailing trends in interior design. Historically, oil paintings were displayed in richly ornamented frames with gold and silver leaf, and many current moulded designs inherit the appearance, if not the luxury, of such classic designs. Nowadays our tastes have moved toward a less decorative style, and it's the picture itself, rather than the frame, that shows the owner's wealth and, hopefully, good taste.

You rarely go wrong with a big black frame like any of these.

Glass

Glass can be taken for granted, but there are many types. Ordinary glass made by the modern float process method is cheap and is perfect for most framing needs, but older picture frames' original glass will be less transparent and have a slightly uneven surface, and can still be found if needed.

Alternative types of glass are also available for specialist applications. Daylight's ultraviolet (UV) rays can do great damage to pictures, and ideally you would not hang a frame in direct sunlight where the paper and inks may degrade, or the frame itself may be affected by heat. If for some reason this is impossible, a number of manufacturers produce glass with higher UV resistance, some cutting UV passage by up to 98%.

Similarly, you may be unable to avoid locating the frame where reflections prevent the picture being seen at its best, or security may also be an issue. In each case, a range of solutions is available, obviously at extra cost, and good framers and conservators should be able to assist with selecting glass to suit other unusual needs.

Color and types of moulding

Henry Ford may or may not have said "any color you like so long as it is black," but it is certainly not a quote from a framer! Indeed for many of us too much choice is the problem, because most framing shops have a wall (or four) full of samples.

Unless you are trying to match an existing frame, you have a wide choice in styles and colors to consider. In addition to more traditional stained, gilded, and painted wood mouldings, suppliers offer modern decorator colors and designs with simple profiles. The choice is boosted by mouldings manufactured

in plastics, which tend to be cheaper; and in aluminum and other metals which suits photographers and interior designers looking for sharp edged style. Wood frames can also be stained to your requirements, so the possibilities really are effectively endless.

Some framing shops have software to help you visualize your picture in all of their moulding patterns and mount colors. This can be a quick and helpful way to supplement the advice that the framer can offer. There are also online services, but nothing beats seeing the real thing.

When you hang pictures together then it is desirable to coordinate the styles and materials both to the picture itself and its near neighbors. The room's furniture and wall coverings also affect the choice of frame, so take the picture itself and any fabric samples, paint colors, and styles from the room and get the advice of a local framer. You will benefit from lots of accumulated experience and knowledge of the materials and any other issues. Be prepared to talk about your budget and what you prefer, but also be open to suggestions. You will quickly establish if they are "on your wavelength."

Wood frames

Wood's great advantage is that the frame can be stained in any color you choose, while retaining its interesting natural texture.

ABOVE: *Sometimes the subject defines the choice of frame—each time I've sold this picture, the customer wanted a metallic finish.*

LEFT: *The beige walls and sepia-blue toning made wood the choice for this picture.*

Borders and proportions

Thinking a little more about the image's relationship to its borders and frame, it soon becomes pretty obvious that while ready-made picture frames and mounts are good value, you don't want to limit yourself to standard sizes. From a creative standpoint, this can easily lead to your cropping images to fit the standard, rather than suiting the picture. We need to move our thinking beyond "what size frame do I need for a 10 x 8 print?" Instead we must open our eyes to the possibilities of creative scale and proportion. Think of adding drama and tension through the placement of the image and the scale of the borders around the image.

A **CUSTOM-MADE** frame removes these mental limitations and gives you full artistic freedom in terms of the scale and proportions of how the image is presented. A good framer will have plenty of experience helping customers decide on framing, and while larger frames will use more materials and be more expensive, the biggest cost is the framer's time, which tends not to be increase in proportion to the dimensions you choose. A larger custom-made frame will also meet the customer's expectations if you are selling the print, or feel more special than an off-the-shelf frame if you are presenting the picture as a gift.

There are really no hard and fast rules about proportion, not least because it's a matter of personal judgment. You need to use your own eyes, and your decision will probably differ from someone else's.

One very helpful idea is to test a sample of mountboard against your print with a pair of L-shaped corners. Have at least one pair with wide light borders, and a second one in black or a dark neutral color. Move them around so you can see their effect on the image. If you're not sure, ask other for other people's views and let them move the templates too. Watch what they do and how they respond to the picture—you can get some great feedback on your print as well. If all else fails, there's always Photoshop; it's very easy indeed to mock up the layout.

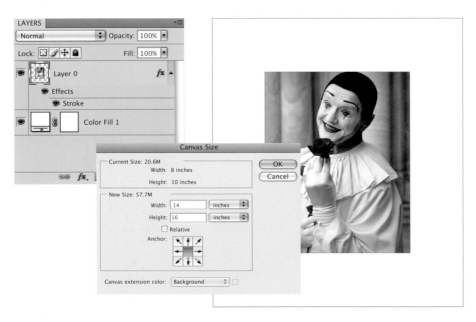

To simulate frames, take a copy of your image in Photoshop, flatten any layers, then use the Image > Canvas Size command to assess how the picture would look with different frame dimensions.

A phyiscal solution is to make a pair of L-plates from mountboard and use them to assess framing and border proportions.

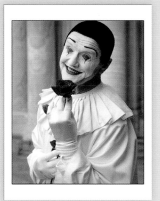

Compare these alternative framings of a 10×8in. (20×25cm) print. To my eyes, the sweet spot is the 14×16 inch (36×41cm) frame—a border that's over a third of the image's width.

9×12 inches (23×30cm) 11×14 inches (28×36cm) 12×14 inches (30×36cm)

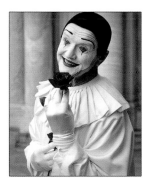

14×16 inches (36×41cm) 14×17 inches (36×43cm) 16×18 inches (41×46cm)

Panoramas

Landscapes look superb as panoramic prints and these can be framed and hung in long, narrow frames.

Limited editions

Established artists with a strong following and demand for their work frequently offer limited edition prints, often through commercial galleries. Below such rarefied heights, the idea may seem a ridiculous affectation, yet the limited edition concept can be applied to digital inkjet prints and has much to offer in terms of building up a reputation and perhaps a market for your work.

THE LIMITED EDITION has a long history. The invention of the printing press meant painters and artists could sell their work to customers unable to afford original paintings. Using traditional printmaking techniques such as etching and engraving, the artist or his studio could reproduce identical prints from a single copper plate. The plate would gradually wear out, and while it could be reworked to allow a second run, the best quality prints came from the original engraving and were more prized.

Silver-halide based photography pushed the boundaries of the limited edition—the negative could potentially be used for an infinite number of prints. But fine art

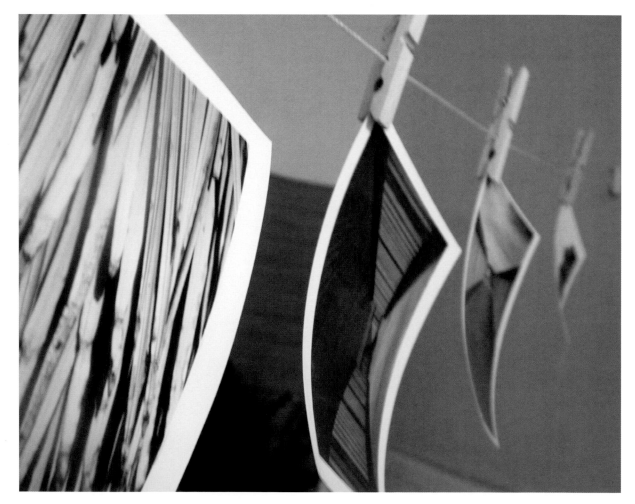

In the days of the darkroom each print was unique, exposed as it was for a different amount of time by manually-operated enlargers and chemical trays.

A digital printer, by comparison to the photographer in his lab, is a simple device executing the same instructions time after time.

photography essentially continued the old tradition, and just as the exhausted copper plate was eventually thrown away, there are some examples of photographers who destroyed their negatives after completing a limited edition. Thankfully that practice was not universal, and it would certainly be hard to implement in today's era of digital imaging and pixel-perfect backups. Instead we have sets of conventions, rules, and legal obligations that have now been put in place to manage the fine art market.

Reproduction: duration and accuracy

It's a widespread assumption that a single digital image can produce an infinite number of identical prints. If we leave to one side the role of the printer, ink, paper, and the human factor, there is at least some truth in seeing the inkjet print as a mere commodity. So the modern concept of the limited edition implies much more than a finite number of prints from a single digital image.

One element is the print's physical composition. While it is conceivable that somewhere there must be a limited edition which was printed down at the local mini-lab, the expectation is that a limited edition print has been made to the highest standards. Since the early 1990s this has meant what was known as the "Giclee print," a term now applied more loosely to high quality inkjet

prints. Epson's UltraChrome ink based printers are now generally regarded as being in this class.

Another important factor is that the limited edition print has some personal connection with the original artist. This would, for instance, include cases such as a posthumous limited edition produced by the artist's estate, but it would exclude an unauthorized high quality print made from a copy of the image file that arrived on someone else's computer.

Archiving and publishing

Many artists will rely upon the services of a publisher to undertake the complexity of printing and publishing their editions. Individual contract arrangements will cover the apportionment of costs and income. In addition, the publisher may be responsible for the archival storage and distribution of the digital files and associated certificates.

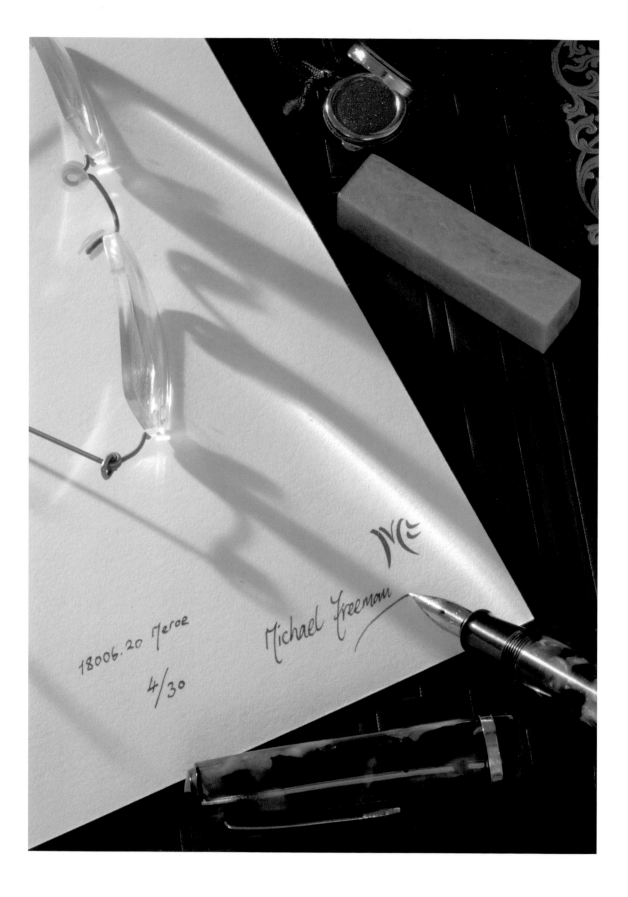

A signed limited edition, together with the edition number and total number of editions (the fourth of thirty) and a reference number for the file.

Signed editions

An artist will only sign a print when completely satisfied with it, and signed limited editions generally attract higher prices than unsigned work. It is standard practice that the number of the print and the edition size are hand-written on each print in the series. Each item from an edition of fifty would be marked—1/50, 2/50…up to 50/50—and signed.

This simple act of declaring that a print forms part of a limited edition is a step toward managing the issues of quality and authority. By producing a smaller quantity the artist is then able to warrant that each print is identical and of fine art quality. Likewise the buyer knows that a finite number of these images will ever be printed.

There is no fixed rule about the maximum size of an edition. There are cases of around 900-1000 copies, but even stretching the numbers into three figures begins to erode one of the key aspects that customers look for: exclusivity.

More reasonable is a limit of 25. One strategy is to base the limit on the dimensions, so there might be 4-5 prints at the very largest size, 10-20 medium, and perhaps 80 smaller ones. Another way to push up the numbers is to offer a black and white version, but just remember that buyers aren't fools.

Once you set a limit, you have to observe it – in spirit as well as to the letter. However, it is not necessary to print all the copies immediately, and printing as required is perfectly acceptable and can make good commercial sense. Just ensure you have your master file, backups, and can easily find the file when it's needed. It's also worth keeping a first-run print for matching.

Printing on-demand also means you need good records of each edition—how else would you know what number to write on a new print? Record who has bought each copy, when, and what was paid. As well as being important for tax and also for your marketing, evidence of a print's provenance can have all sorts of other benefits, not least as legal evidence in the case of a dispute.

Signing limited edition prints

Limited edition prints may be hand-signed directly on the image, but it is more usual to add the information on the back of the print or below the image in the lower margin, where it will show in the window mount. We're very much in the realm of personal preference, but often any title and the print number go in the lower left corner, and the artist's signature goes in the lower right. But it doesn't really matter if you prefer things the other way round, and some artists will also title the print in the center between the two. All of this would normally be in the artist's hand in pencil.

Sometimes the subject might also sign a limited edition print alongside the artist. If they are themselves a well-known name this endorsement can add extra value to the print.

Signing an edition will take some time and will require a consistent signature on each print. People must be able to read it. An illegible signature isn't a sign of creativity and it doesn't add a level of intrigue to the painting. If the signature on the first and last print is the same this is a sign that the task has been done well. So practice on some spare paper, and try out different grades of pencil or pen.

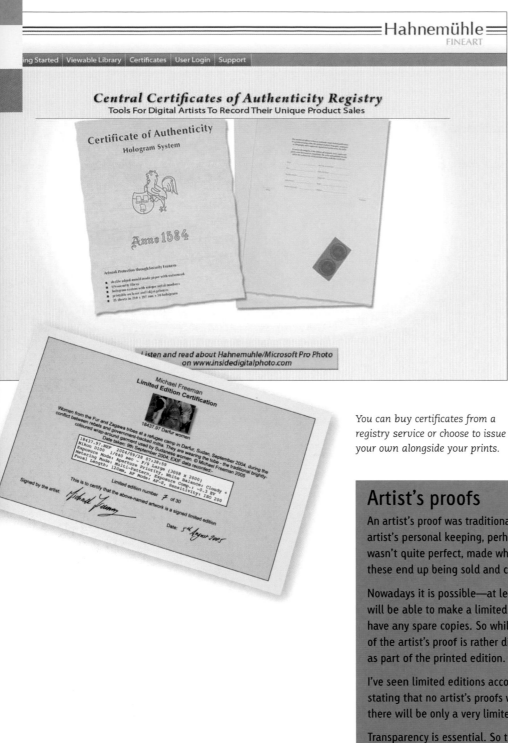

You can buy certificates from a registry service or choose to issue your own alongside your prints.

Certificates

One idea is to accompany your print with a certificate of some kind. It is by no means standard practice in the fine art market and can easily appear pretentious. In fact it offers no greater guarantee of provenance than your invoice or other correspondence with the customer. It could be added that the signature and edition information on the back of a print serves the same purpose, and cannot be separated from the work.

But nevertheless there have been several systems of authentication devised by publishers, professional bodies, and even lawmakers, and in some legal jurisdictions a certificate of authenticity is actually a requirement of a limited edition.

Any certificate would need to include the name of the print, its dimensions, the media, and the number of the print in the edition, plus the number of total signed and numbered prints that will be published.

Artist's proofs

An artist's proof was traditionally a print made for the artist's personal keeping, perhaps a variant or a copy that wasn't quite perfect, made while setting up. Eventually these end up being sold and can be prized.

Nowadays it is possible—at least in theory—that you will be able to make a limited edition inkjet print and not have any spare copies. So while it remains, the concept of the artist's proof is rather different in that it is seen as part of the printed edition.

I've seen limited editions accompanied by small print stating that no artist's proofs will be produced, or that there will be only a very limited number, 1 or 2.

Transparency is essential. So there is no confusion, the artist's proofs should be included within the edition numbering and record keeping system. It doesn't hurt either to mark them perhaps with the abbreviation "AP" in the work's lower left corner.

The paper manufacturer Hahnemühle is particularly strong in the fine art market and offers a self-certification system. Each certificate is made of deckle edged mould made paper with a Hahnemühle watermark and security fibres, and corresponding holograms are added to the certificate and to the print's reverse side. The holograms are sequentially numbered in matching pairs, so the combination of certificate and hologram ensures that each certificate relates to a specific print. This is a reputable system and may be ideal for individual artists without the support of a gallery or publisher.

Embossing

Embossing is a long-established way for an artist to mark up the print and further guarantee its authenticity. While the embossing press may seem a little expensive, it also lasts a lifetime. Individual stamps are made to order and usually contain a logo or the artist's name, sometimes allowing space for the limited edition's "x of y" numbering.

Though some artists like the stamp to intrude on a corner of the actual image, it's more usual to add the mark to the print's border, often in one of the lower corners, and perhaps so it can show up in the window mount. Wherever you choose, though, the embossing remains a subtle, rather tasteful, finishing touch.

An embossing press; not all are quite this elegant in their design but the principle is the same; the lever pushes opposing designs together creasing the paper.

Embossed marks need to be made to order, so it's an expensive solution, but you only need to do it once.

Hanging a single print

Hanging a picture is often the final destination in the picture's long journey from the camera. It's a task that requires some practical skills, which may come naturally if you do a lot of jobs around the house, or you may consider getting help from a professional if the frame is particularly large or heavy, or if it needs a picture light or a spotlight in the ceiling.

AVOID HANGING PICTURES over a source of heat like a radiator, in direct sunlight or very bright light conditions, as these can all harm the artwork. And think twice before you hang a picture above something fragile such as glass or china. Move anything out of the way—accidents happen.

Even when the picture is small, you should spare a moment's thought to the wall's composition. Is it solid, or is it a partition and will it be strong enough to support the weight of the frame? You also need to look for any electric, computer, or telephone cabling, or for water pipes. One picture hook can do a lot of damage.

You can hang light pictures on a partition wall with a simple picture hook, but there will be no support other than the plasterboard. For medium to heavyweight pictures you will need to ensure the internal frame of the partition carries the weight, or hang the picture from an external rail or hanging system. In either case you may need to get help or advice.

The height at which you hang pictures needs to be at a comfortable viewing level. This isn't always easy to judge, especially for those of us above average height, but one guide is that the eye should be near the

A heavier duty metal fixing will use three or more nails. Notice how the nail is driven downward into the wall.

Wire fittings let you adjust the individual hanging height much more easily than retying cord

midpoint of the picture or slightly above. On average, this will be roughly 66 inches. It's worth trying things out before you commit to making a hole, possibly holding the frame to the wall or attaching an unframed print with Buddies or Blu-tack. This will give you a much better idea of how the frame will look.

Fixings

On the reverse of a picture frame there will be fixings appropriate to the width, the frame material, and the weight of the picture. These can be used with picture cord, wire, or chain, and you can also get fittings which lock the pictures to the wall if you need added security against theft or want to hang the frame in a busy areas where there's a risk that it might get knocked.

On the back of the picture, the framer will have attached a picture cord to fixings on the frame edge. This cord carries the weight of the picture and it is best if the cord is able to spread that weight between the two fixings.

As a finishing touch, fit the lower two corners of the frame with clear rubber or white felt bumpers. These protect the wall, allow air to circulate around the rear of the frame and help to stop the picture from moving. You will spend less of your life making sure the picture is level.

Using two wall fixings

The heavier the frame, the more you need to use two wall fixings to distributes the weight. It also allows you to easily adjust the level of the picture later.

1 Measure half the width of the frame, so if the frame measures 28 inches (72cm) wide, the hangers would be spaced 14 inches (36cm) apart.

2 Determine the height to the center of the picture. This will be around 66 inches (168cm) unless there is furniture underneath when a judgment should be made.

3 Hold the picture cord on the back of the frame tight. Keep your fingers apart by the distance established in step one. Measure the distance from the center of the frame up to the wire (say 6 inches or 15cm).

4 You will need to ensure that the two hooks are fixed 72 inches (66+6 inches) (183cm, 168+ 15cm) from the ground and 14 inches (36cm) apart.

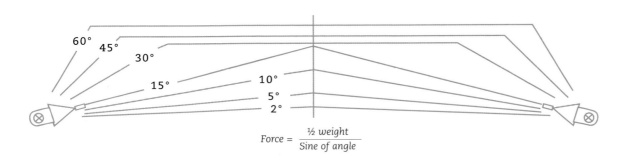

$$Force = \frac{\frac{1}{2}\ weight}{Sine\ of\ angle}$$

For every 10lbs (4.5kg) of picture, these are the forces pulling on each wire anchor point:

60° = 6lbs (2.7kg)
45° = 7lbs (3.2kg)
30° = 10lbs (4.5kg)
15° = 19lbs (8.6kg)
10° = 29lbs (13.2kg)
5° = 57lbs (25.9kg)
2° = 143lbs (64.9kg)

Hanging multiple prints

When you are displaying a group of pictures, all the practical issues of hanging one picture are compounded by the need to arrange and align several prints. There are a number of rules you can apply, yet every situation will be different and you will need to see this task as a mixture of practical and visual issues.

THIS IS NOT a job to be rushed. A little bit of careful planning with a scaled drawing will help you to think through the general layout. This will help you to look at the balance of sizes and shapes, and to plan groupings and alignments (informal, formal, and relative spacing). Then, with some plain colored paper and Buddies or Blu-tack, you will be able to test the layout at life-size. That way you can try out one or two different options without making a single hole in the wall.

It's no bad thing that the layout will often be a compromise, where some interesting possibilities may need to be jettisoned for the best end result. The eye may indicate that a group of pictures looks better when positioned deliberately off-center rather than exactly in the middle as measured with a laser level and tape measures. It's a creative process rather than a cold mathematical one.

As well as variation in frame shapes and sizes, you may well have to accommodate different frames and colors. Try laying the pictures side by side on a white or pale

Picture frames are best supported by hooks nailed into the wall.

Here the frames are hung at even intervals and are fixed securely in this busy stairwell.

cotton sheet on the floor, and be brutally honest—does that gold frame really look good next to the painted wood one? If not, consider a different group or changing the choice of frame.

You will find some gilded finish frames work with others with slightly different moulding design, or the juxtaposition of high decoration and plain wood finishes may be striking. After all, you are not seeking uniformity, but harmony and visual interest. But once you begin to notice the frame, rather than the print, that's a sure sign that something's wrong and you need to review the hanging plan.

The content of your prints is also likely to affect how you group the pictures. Abstract art images might demand some breathing space, while a group of related photographs may benefit from being placed closer together, or facing one another.

Also be aware of how you want the pictures to be viewed, and which is your favorite or "key" picture. Locate that frame at the center of your plan, in the best position, and then work out the grouping around it. Make sure any key pictures are well lit and at a perfect viewing height.

Should you align the tops, the bottoms, or match up the centers? It's again a matter of judgment, but as a first option always consider the frame center as the critical positioning point. This is especially tricky when arranging pictures along a corridor or up a flight of stairs.

Whether you are looking to create an exhibition or a grouping of prints for your home you may find it helpful to work with others in order to reach agreement on the

Hanging these prints in groups produces a more interesting, less metronomic effect.

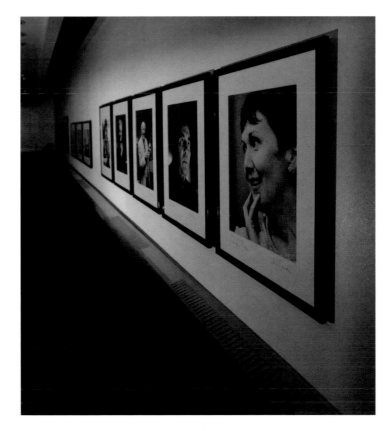

Each group of frames consists of only vertical or horizontal format images, and close up shots are also hung next to each other.

layout and placement of your best pictures. But don't expect to always agree with one another, and remember that there are probably multiple solutions that will work.

Assessing the space

As the first step to hanging your prints in any exhibition space then you'll need to make an assessment of that space and how you can best work with it. You may well have the opportunity to exhibit in a mixture of venues; perhaps libraries, coffee shops, bars and restaurants, or a health club, as well as a purpose-built gallery space. Not all will be ideal so you need to draw up a short list and choose the most suitable.

NON-TRADITIONAL EXHIBITION spaces may be more difficult for you to use as they may not be used to working with an artist and may lack certain facilities. However, they may be perfect for showing your work to the wider public in an accessible way. After all, if they are already busy, popular spaces then you have a potentially large audience for your work. But, if you are hoping to sell your work, this audience may not translate into potential customers. Make it part of your assessment to talk to previous exhibitors as well as the space owners.

Having made a short list of alternatives you will need to visit each venue, introduce yourself, and assess the space for lighting; color, surface covering, and size of walls. Does the mood suit your exhibition's theme and content? Do the owners have sympathy for your objectives and needs?

In a gallery space you would expect to find plain white walls with a mixture of natural and general fluorescent lighting. They may well have plans for you to use to take notes of any issues and to take away. (If not be prepared with equipment to measure and sketch your own plan). They will also know how to use the space to best advantage having experienced other shows so ensure you ask for as much as you need. Also get a clear understanding of the costs and services provided (such as promotional support, private viewing, and staffing). You will need to talk about commission and other costs if you intend to sell your work.

At your visit you will quickly get an approximate feel for your ability to fill the space and whether it is too large or too small for your needs. If the space turns out to be just a little bit too small you can be flexible in how much you hang (or with the print sizes). If you feel the space is too big, the only option might be to share it with another, carefully selected artist-friend or wait to join in with an open exhibition. Be realistic for your first shows.

First impressions count. You need to look at the space as if you were a visitor. Is it welcoming and brightly lit? Is it warm, well carpeted and what is the state of the decor? Finally, are there any smells or obtrusive noises that would be a problem? Having looked around, make an overall sketch of the shape and layout of the room with all doors and windows clearly marked.

Make a note of the major spaces that are best for hanging your pictures. Sketch each wall noting any issues (power outlets, switches, and security systems for example) and take a photograph noting the location on your plan. Measure and note as accurately as you can, as you will be using these sketches to plan the exhibition later.

A major issue for you will be whether the space has suitable hanging supports installed which allow for vertical and horizontal adjustment of your frames. This feature will enable you to hang your pictures using security fittings and to make alterations during the course of the exhibition should that be necessary. If the space has installed a hanging system then it may also have track lighting to illuminate your work. This will be a major benefit to you.

A unique exhibition of black-and-white prints arranged so that the display itself becomes an artwork. Each wood mount can be individually removed and handled. Prints © Sue Callister and Alberto Saro.

You are likely to need to do a lot more basic work in a non-gallery space, but the hire cost will reflect that. If the space has no hanging options then you will need to establish what is allowed. In a public area you will need to be able to secure your work and may also need to ensure the exhibition is staffed at all times. Consider the use of mirror plates and security screws; these can be painted white or covered to match the wall covering and minimize their visual impact. These can be filled and repainted after the show, but you will need to get permission for making attachments to others' walls.

Armed with your detailed sketches you can begin to plan your layout and make accurate drawings for the show. The size of the space will have a bearing on the print sizes you might need to use along with the number of images. 16 × 12 inch (approximately A3) prints would be a normal choice for a photographic print for display. If you have a key print or image to support the theme then you might consider a larger print at the entry door.

If your venue has a number of interlinked rooms, you will need to construct a route through and then use the layout, size, or content of your images to change the mood or direct the flow. If possible, see a show at the venue to see how other artists utilize the space.

You will need to decide on the style of mounting and framing that suits your needs. Are you taking the show to a number of venues? Do you intend to sell prints? Is the show staffed? All have a bearing.

Consider exhibiting in a temporary frame and provide a conservation frame, which meets your customers' requirements when sold. If you work at a standard size then you will be able to keep a stock of temporary exhibition frames that suit your style.

Photographs can be exhibited simply as mounted prints with double sided tape, staples, or Velcro dots. Sales will always be of a new print, mounted or framed by request.

For any exhibition you should provide information about yourself and your work. Each picture should be captioned clearly showing as a minimum the title and whether the picture is an original, or a print and the medium and date. It is the convention to list prices and availability on a separate typed list rather than beside the print.

When you are this well prepared, the hanging of the show will be so much easier.

Knowing the size of the space allows you to fit your prints into the place they seem most comfortable.
© Sue Callister and Alberto Saro.

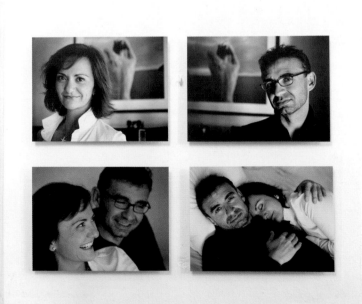

This acrylic mount held some distance away from the wall has an apparent life of its own.
© Sue Callister and Alberto Saro.

Self assembly books

As well as in frames and albums, the book is another long-established way to display picture. Digital imaging and faster internet connections now offer new ways to make your own book, and there are services where you upload your images and can have copies printed one at a time. Some are basic consumer-oriented sites, but more professional services are emerging all the time, offering advanced features like color management.

ANOTHER HIGH QUALITY solution is to make the book yourself. You print the pictures on your own printer, in some cases using double-sided inkjet paper, and then assemble all the sheets into a book. This doesn't mean you need to acquire the skills of traditional bookbinding, however, because inkjet paper manufacturers such as Innova and Permajet offer easy alternatives which anyone can master and which allow the artist to produce unique books as portfolios or gifts.

With kits like the Permajet PhotoBook it's easy to take your prints and assemble them in a presentation book without learning true bookbinding skills.

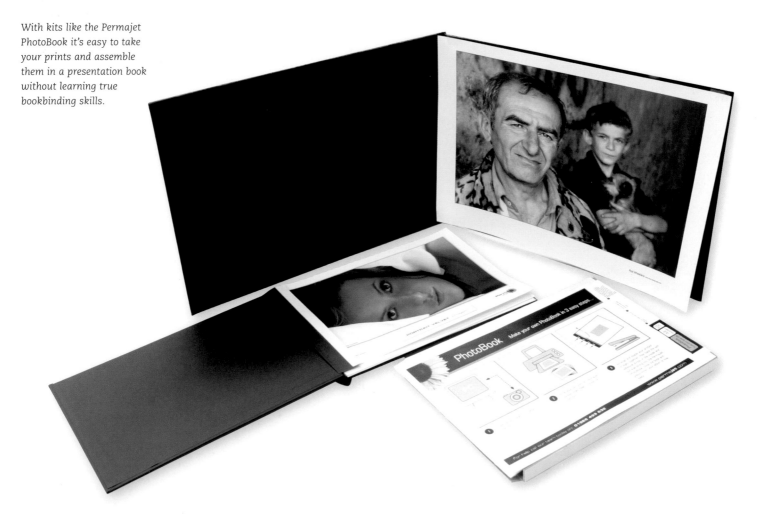

Assembling the book

1 Generally these books work best if you use double-sided inkjet paper, printing on both sides if you wish. In some cases you need to use pre-hinged sheets, but most self-assembly books, such as those offered by Permajet, allow you to choose your own paper. It's generally a good idea to be consistent and not mix gloss, lustre, and matt finishes. That said, such "rules" can be broken.

3 You may have a very good idea of the page order before you begin work, and can fit the sleeves or holders into the book spine as and when they are ready. Realistically that's not always the case, and it's no bad thing to change your mind as you work, so it makes most sense to prepare all the sheets before fitting them into the book spine. This allows you to lay them out and perhaps swap things round, just to see what works best. When you're ready, slide them into the spine or book cover as stated in the manufacturer's instructions.

2 The different systems rely on mounting the paper in some sort of sleeve or holder, which can then be fitted into the book's spine. Here a sheet is being stapled between two covers, though adhesives are also available.

4 The final stage is often to attach the cover. Again, the methods vary— here it's a simple case of peeling back a strip of plastic and revealing a self-adhesive strip. You then align the cover with the spine, and press hard.

Troubleshooting

As inkjet printers are highly sophisticated machines, things do occasionally go wrong. Sometimes the error is obvious—for instance when you forget you have plain paper in the printer—but here are a few of the more common printer problems that you may encounter, and some ideas about how to fix them. Always remember problems can often be really specific to certain printer and paper combinations, so make sure you read and understand the manuals and accompanying literature.

Unexpectedly poor print quality

A mistake that is very easily made, especially with smooth or matt-finish papers on which it's difficult to tell the correct side to print, is to feed the paper facing up the wrong way. As the wrong side is not coated to receive ink, the print can appear smeared and colors can be abnormal. To verify that this is what you have done, wait until the ink is dry, then re-feed the paper the other way up, and run a test print.

Paper cockling

This problem arises when too much ink is laid down onto the photo paper, causing the paper to become saturated. It suggests that the wrong driver setting, or paper type, has been selected, or the wrong paper type is loaded into the printer.

Ink pooling on paper surface

If ink starts to lie in pools on the surface of a print instead of being absorbed into the paper surface, there are two likely culprits. You might have fed the paper into the printer upside down, but another possibility is that the wrong paper type has been selected in the printer driver and has made the printer lay down too much ink.

Noticeable color cast

If you notice your print has a color cast that differs from the screen, check all the paper settings are correct in the printer driver. One possibility is that some or all of the nozzles that channel ink from one of the ink cartridges may have become blocked. Run a nozzle check or take out the cartridge and shake it gently, perhaps tapping it firmly with your finger.

Also, consider the light source under which you are examining the print. Artificial light can produce a color shift, most noticeably with black-and-white prints or in the grayscale areas of color prints where a regular domestic tungsten lightbulb can reveal magenta and green tones. One solution is to review the print in daylight or under a daylight-balanced lamp, but we will see more about this issue later in the book.

Profile mismatch

If the color management settings on the printer driver, or the printing application, or both are set incorrectly, the result is likely to be incorrect color and print density. It pays to fully understand how your software application and the printer driver work together and to know exactly how to correctly set up the color management. Later in this book we have a special section dedicated to color management.

Close up of a print head in need of cleaning. This ink head has three sets of nozzels for each of the cyan, magenta, and yellow inks, but spray has built up on the surface mixing into a messy pattern.

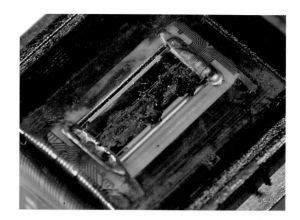

Empty or blocked cartridge

Original image

Result of an empty ink tank, or failed nozzels on magenta cartridge

Glossary

Absolute colorimetric
A rendering intent where the software clips colors which cannot be reproduced by the printer but without remapping the whites. If clipping leaves the whites with a slight cast, that is how they will be output.

Acid free
A quality of inkjet paper where the maker has eliminated acids from its manufacture with the goal of increasing archival longevity.

Actions
Keystrokes recorded in Photoshop and used to automate routine activity.

Adjustment layer
In Photoshop, a type of layer whose purpose is to adjust the appearance of pixel layers beneath it in the layer stack.

Adobe Camera Raw
In Adobe Photoshop and Bridge, the module responsible for converting raw image data from a digital camera into TIFF image data.

Alpha cellulose
The purest form of cellulose and constituent of high quality inkjet paper.

Alpha channel
A grayscale version of the image that can be used with the color channels for saving a mask or selection.

Apple Aperture
An image editing and management program from Apple, limited to the Mac OS X operating system.

Artifacts (artefacts)

Extraneous shapes degrading a digital image and produced as a result of its capture, manipulation, or output.

Baryta
Barium-sulphate, a clay-like material applied to traditional fibre-based photographic paper substrate, and now being used to add a smooth reflective surface.

Blending mode
The method by which Photoshop and other imaging applications combine layers of color information to produce a composite result.

Bronzing
A visual effect where the print appears darkened or "bronzed" where ink has been laid down, and contrasts to highlight areas where there is little or no ink.

Bubble jet
Canon's traditional inkjet technology where the ink is fired onto the paper by being heated and converted to vapor.

Burnt out
Containing no detail, usually referring to overexposed parts of an image.

Capture sharpening
A small amount of sharpening added to an image to compensate for the inherent lack of sharpness in pixel-based captures.

Clipping
An absence of detail in image areas because the brightness values record either complete black or pure white.

CMYK
One of the main ways of defining image color and brightness—Cyan, Magenta, Yellow, Key (black).

Color (blending mode)
In Photoshop, a blending mode which allows pixel color values to be adjusted so that the hue or color is altered but pixel brightness remains unchanged.

Colorimeter
Equipment used to profile and calibrate screens, printers and other digital imaging output devices

Color management
The practice of calibrating and consistently passing image information between the devices (screens, printers) involved in the printing process

Color space
A mathematical model which numerically describes colors in terms of three or four values or color values. Examples include RGB and CMYK.

Continuous flow systems
A system of bottles and tubes that supplies ink to the printer.

Creative sharpening
Additional sharpening applied to parts of a digital image, such as the eyes, to improve the appearance of certain features.

Curves
In Photoshop, a method of controlling how an image's "input" brightness values are output.

D50
A name for light sources balanced at 5000°K and a good match for daylight.

Derivative
An image file produced from an original, for instance the JPEG or PSD file saved after a Raw or DNG original has been edited in Photoshop.

Destructive editing
Permanent change of pixels' brightness values or positions.

DNG
Digital Negative, an openly-documented digital photograph format sponsored by Adobe and containing the Raw image data and XMP metadata. Considered as an original.

Dye
A type of ink that soaks into the paper.

Edge burning
The darkening of a picture's edges to compensate for the distracting brightness of any paper around the image.

Feathering
In Photoshop, softening the edges of a selection so that transition effects re less noticeable.

Fibre based
A type of photo printing paper based on cellulose fibres where the printing surface or substrate is the paper and not a plastic surface as in "resin-coated" papers.

Filter (PS)
A Photoshop change applied to pixels in the active layer or selection.

Gamut
The range of colors which can be accurately represented by a color space or by a printer, screen or other output device.

Giclée
Originally used for prints made from the early 1990's on the Iris Graphics inkjet printers, but now applied to all archival standard inkjet prints including those from Epson UltraChrome printers.

Grayscale
An image containing shades of gray as well as black and white.

Head cleaning
An inkjet maintenance procedure where the printer empties and refreshes all color nozzles, performed when output quality diminishes or during startup or after cartridge change.

HSL
Hue Saturation Lightness. An alternative representation of the RGB color space which describes colors in terms of hue, saturation, and lightness values.

Hue
One of the main properties of a color and commonly using terms such as "red" or "orange". The two other main properties of a color are lightness/brightness and saturation.

ICC profile
In color management, data that defines the color performance of input or output devices, following the standards of the International Color Consortium (ICC).

Image mode
Method of recording color and brightness in a digital image file.

Instruction sets
Processing metadata, the record of steps taken to edit an image.

Interpolation
The addition or deletion of pixels when Photoshop resizes an image.

ISO
Measure of sensitivity to light ("speed") as set by the International Standards Organisation.

JPEG
A digital image file format which compresses file size by the removal of unused color data.

K3

Epson UltraChrome K3 ink with a third black ink to provide more neutral grays and improve tonal gradation for both black and white and color printing.

LAB

A color model designed to approximate human vision. Colors are described in terms of an L for lightness and a and b for the color values

Lab mode

An image mode in Photoshop, often used for making color corrections which its proponents argue (erroneously) are otherwise impossible in Photoshop's RGB mode.

Layer

In Photoshop, a level of the image file to which changes can be independently applied.

Lightroom

An image editing and management program from Adobe, available for Windows and Mac OSX operating systems.

Lignin

A compound derived from wood and present in paper, responsible for paper yellowing with age. Lignin is removed from the pulp in the manufacture of archival quality paper.

Limited edition

A collection of prints where the artist limits the number of identical images that will be made.

Lossy

A file format which loses image information in order to compress file size; opposite of lossless.

Luminosity (blending mode)

In Photoshop, a blending mode where pixel color values are adjusted so that brightness changes but the hue or color is unaffected. Commonly used in sharpening to prevent the appearance of color anomalies.

Marquee

A Photoshop tool to select image areas.

Masking

A Photoshop technique where parts of an image layers are excluded from the composite image.

Metadata-driven editor

An image editor that processes digital images by recording in its database the instructions to adjust the color and brightness and other characteristics, and only performing those editing steps on the actual image when instructed to render a derivative file or output a print. Examples include Apple Aperture and Adobe Lightroom.

Metamerism

The phenomenon where colors change due to different light sources—particularly affecting black and white prints.

Monitor profiling

The calibration or measurement of a computer screen's color and luminosity characteristics

Non-destructive editing

The practice of editing image data which attempts to separate adjustments from the image data, so that those adjustments remain permanently editable and can be revised or removed at a later date.

Nozzle check

An inkjet maintenance procedure where the printer makes a print with a standard pattern and used to ensure all color nozzles are performing correctly.

OBA

See Optical brightening agents.

Optical brightening agents

Ultraviolet-absorbent dyes that re-emit light in the blue region, often added to paper to make it appear whiter and less yellow. As these properties diminish over time, archival quality papers typically do not include optical brightening agents.

Output sharpening

Extra sharpening added to a digital image, specifically to improve the sharpness of the printed output.

Perceptual intent

A rendering intent that compresses the colors to the color gamut of your paper, while preserving the relationships between those colors, so their relationship appears right even if they are not totally accurate.

Piezo
Epson's standard inkjet technology where ink is fired onto the paper using electromechanical force.

Pigment
A type of ink consisting of particles that lie on top of the paper.

Preset
In Lightroom, a stored set of editing instructions, metadata, slideshow, web gallery, or print layouts.

Print profile
Data defining the characteristics of a certain combination of printer, inks, and paper, and produced by measurement with a colorimeter as part of a color managed workflow.

Print sharpening
See output sharpening

RC
See resin-coated.

Relative Colorimetric
A general-purpose rendering intent where the software maps the white in the image to the white of the paper profile so that whites in the print are represented by the white of the paper. Clipped colors are mapped to the nearest in-gamut color.

Rendering Intent
The method of adjusting color data sent to the printer to compensate for clipping.

Resin-coated
A type of photo printing paper where the paper is enveloped in plastic and the image is laid down upon this plastic surface.

RGB
The primary colors of the additive color model, used for recording image colors on monitors and for image editing.

Saturation
The purity of color, with high saturation being most intense.

Sharpening
The identification of edges in a digital image and the addition of halos along them, with the goal of improving the apparent sharpness of image detail.

Smart object
A Photoshop technique where the image data is encased in a special type of image layer which accepts adjustments and other image manipulation, but where the original appearance can be restored.

Soft proofing
A color management procedure where the software simulates the final output appearance by applying printer profiles to the image. Used to compensate for the differences between on-screen appearance and the printer's calibrated output.

Split tone
The addition of one or more tones to a monochrome image.

Template
In Lightroom, a stored set of editing instructions, metadata, slideshow, web gallery, or print layouts.

TIFF
Tagged Image File Format, a file format for high-resolution graphics, widely compatible with other operating systems.

UltraChrome
Epson brand of pigment-based ink using a number of colors, including two types of black, where the standard photo black ink is replaceable with the optional matte black ink for better reproduction quality on all matte papers.

Unsharp mask
In Photoshop, a sharpening method which increases the apparent detail of an image.

Index

Acknowledgments

Michael Freeman
Would like to thank Sue Callister and her husband Alberto Saro
for their help with the gallery and hanging photos.

John Beardsworth
To my mother, always in my thoughts, and to my family, not least the
latest four-legged arrival, Charlie. Also a big hug to Laura Zuccaro for
always keeping that sweet promise. And lastly to Nemanja Vidic and
Federico Macheda.